SOUTH KENSINGTON
THROUGH TIME
Brian Girling

AMBERLEY PUBLISHING

Front cover: Cromwell Place, *c.* 1906.
Back cover: Brompton Road by Montpelier Street, *c.* 1908.

First published 2014

Amberley Publishing
The Hill, Stroud, Gloucestershire, GL5 4EP
www.amberley-books.com

Copyright © Brian Girling, 2014

The right of Brian Girling to be identified as the Author
of this work has been asserted in accordance with the
Copyrights, Designs and Patents Act 1988.

ISBN 978 1 4456 2152 4 (print)
ISBN 978 1 4456 2158 6 (ebook)

British Library Cataloguing in Publication Data.
A catalogue record for this book is available from the
British Library.

Typesetting by Amberley Publishing.
Printed in Great Britain.

Introduction

When London's Great Exhibition was held at the first Crystal Palace in Hyde Park in 1851, the area we now know as South Kensington was already beginning its transformation from a fertile stretch of rural Middlesex into the sophisticated townscape we know today. The Crystal Palace looked south towards the old village of Brompton, with its fruitful acres given over to nurseries and market gardens, while spacious country houses offered the well-to-do a peaceful retreat from the great city to the east.

There were also modest cottages along the lanes, but ribbons of new buildings were beginning to take their place as rural roads evolved into the busy highways of the present day. Local landowners were also developing their estates, with new streets lined at first by plain brick houses in the Georgian tradition and then in the fashionable new style of tall Italianate townhouses in stuccoed terraces – the definitive style for the new London quarter of South Kensington.

Building continued throughout the Victorian era and was given impetus in the 1860s when the district was linked to the capital by the new Underground railway.

The later Victorian era also introduced a more homely red-brick style, while blocks of mansion flats and smart apartments reflected another new fashion in city living.

It was, however, the spectacular exhibition of 1851 that initiated the unique cultural and educational role for which South Kensington became famous.

Under the guidance of the charismatic Prince Albert, Consort of Queen Victoria, the exhibition generated such profits that 88 acres south of Hyde Park and Kensington Gardens was acquired for the creation of a new urban hub of art, scholarship and music. Early manifestations of this 'Albertopolis' included the Royal Albert Hall, which was opened by Queen Victoria in 1871; the South Kensington Museum (1850s); a complex of assorted buildings housing collections devoted to science and the arts, all united by the Edwardians as the mighty Victoria & Albert Museum; and, in 1913, the Science Museum.

Much has been written of the illustrious personalities who have inhabited South Kensington's grand houses and stylish streets, but this book ventures into a different mode, looking instead at the way photography has recorded the changing face of South Kensington from Victorian times to the 1960s and then into the present day, with comparison images taken from as close to original viewpoints as modern conditions allow. We can therefore look again at what the Victorians and Edwardians saw, including the beautiful formal gardens where much of the Imperial College and other illustrious institutions now stand; elegant (and less elegant) streets pictured in their early days when filled with carriages and hansom cabs; domestic stores that evolved into the smart emporia of the present day; and old pubs that were once the preserve of coachmen, cab drivers and grooms.

South Kensington Through Time concludes with a look at the phenomenon of the Kensington mews, half-hidden worlds behind the great houses where carriages and horses were stabled before they were ousted by the rise of the motor car and by a post-war fashion for extravagant house conversions.

It is hoped that this book will appeal to those who have known and loved this unique corner of London through the decades, and to the vast number of visitors who come from far and wide to enjoy the great cultural institutions and museums for which South Kensington is famed worldwide.

Acknowledgements

Grateful thanks are offered to Maurice Friedman and to TfL – the London Transport Museum Collection – for kindly allowing the inclusion of their images in this book. Additional research by Ian Vanlint is also gratefully acknowledged.

Additionally, tribute should be paid to the early photographers whose legacy allows us such a vivid recall of past times. Notably among them was Edwin Cook of Fulham Road, whose photography for the then new medium of the picture postcard wonderfully captured the essence of Edwardian South Kensington.

Books consulted include: *The Buildings of England: London Vol. III* by Bridget Cherry and Nikolaus Pevsner; *The London Encyclopaedia* by Ben Weinreb and Christopher Hibbert; *The Survey of London Vol. XXXVIII*; *Earl's Court and Brompton Past* by Richard Tames; and *Kensington and Chelsea in Old Photographs* by Barbara Denny and Carolyn Starren.

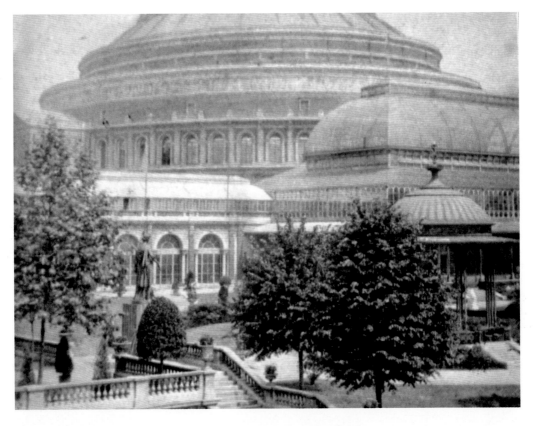

The Royal Albert Hall from the Future Site of Prince Consort Road
Queen Victoria laid the foundation stone of this world-renowned concert hall in 1867; it was located between Kensington Gardens and the Royal Horticultural Society's garden, the viewpoint of this photograph. The gardens were a popular resort for Londoners between the 1860s and 1880s, and facilities included a grand conservatory (1861) and a pair of 'band houses' alongside exhibition galleries. The photograph was taken at the time of the International Exhibition of 1871.

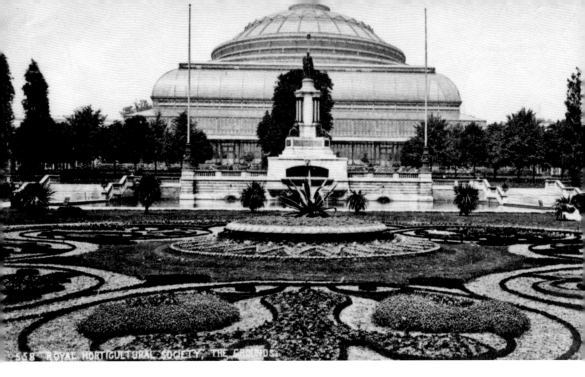

The Royal Albert Hall From the Royal Horticultural Society's Gardens, *c.* 1875

The gardens featured colourful horticultural displays and a vast conservatory, which partly blocks the view of the Royal Albert Hall here. There were also sporting facilities, including bowls, but it all dwindled away in the late 1880s as new buildings encroached upon the grounds. The large statue seen in both images commemorates the Great Exhibition of 1851 in Hyde Park.

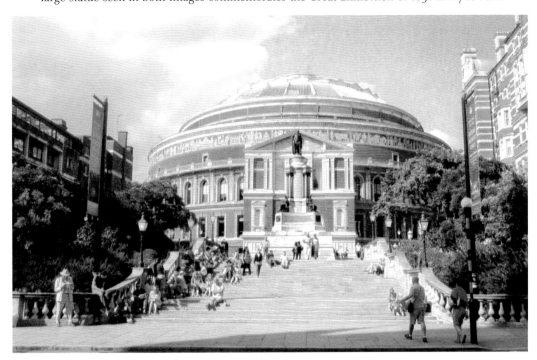

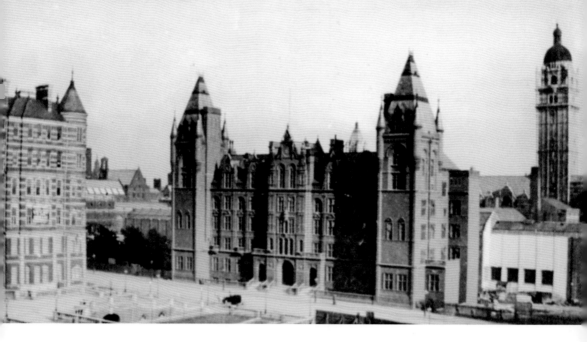

The Royal College of Music, Prince Consort Road, *c.* 1895
Built on part of the former gardens of the Royal Horticultural Society, the college as designed by Sir A. W. Blomfield is seen shortly after completion. Also seen here are the new flats of Albert Court (1890–1900), which brought a residential element into this new cultural and academic quarter. The Imperial Institute towers high to the right of the image, a view since lost when, in 1931, Imperial College's Beit building filled the foreground.

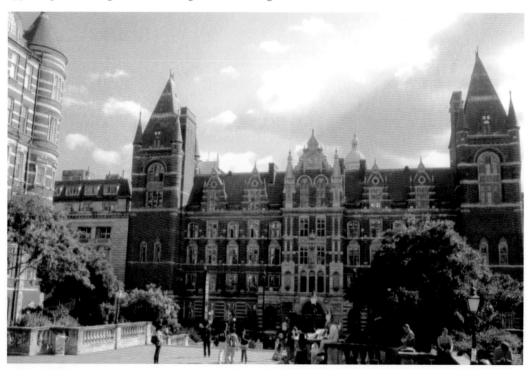

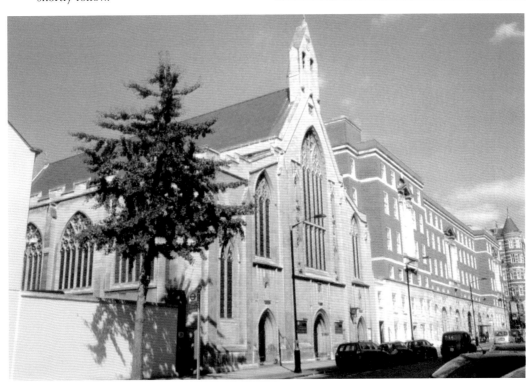

Holy Trinity, Prince Consort Road, *c.* 1905
Prince Consort Road was a new street
laid out from 1888 to 1892 across the old
gardens of the Royal Horticultural Society.
It connected Prince Albert Road (later
Queen's Gate) and Exhibition Road. The
street became noted for its handsome new
buildings, among which was Holy Trinity
church, designed by G. F. Bodley and begun
in 1903. The photograph catches the first
phase of church building – the western
section with its fine Gothic windows would
shortly follow.

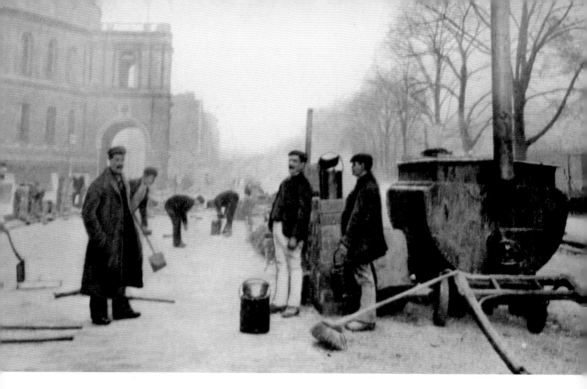

Laying Wood Block Paving, Kensington Gore by the Royal Albert Hall, *c.* 1900
The wooden paving of Victorian and Edwardian London has been lost to us – it provided a good alternative to the many unmade roads of that era, which could alternate between mud and dust according to the weather. The wooden blocks were surprisingly durable, some lasting into post-war years despite being meant for horse-drawn traffic – the advent of rubber tyres meant they could be slippery. Here a road gang is also overlaying the blocks with molten tar, producing one of the characteristic aromas of old London.

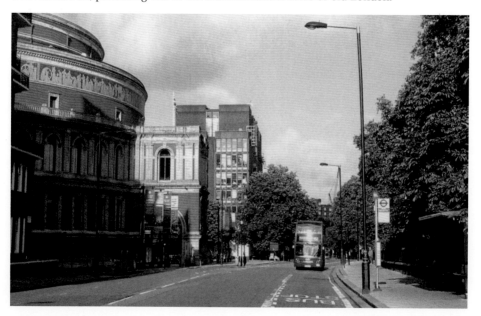

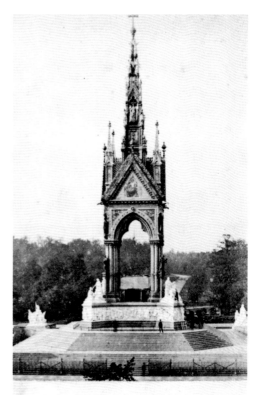

**The Albert Memorial,
Kensington Gardens,** *c.* **1872**
A suitably grandiose memorial to the man
whose vision led to the creation of the
scientific, educational and cultural hub at
South Kensington we know today. Prince
Albert was Queen Victoria's consort, and it
was his efforts that ensured that the Great
Exhibition of 1851 was a financial and cultural
triumph. Prince Albert died in 1861 and his
memorial as designed by Sir George Gilbert
Scott was completed in 1876 when the
gilded statue of Prince Albert was installed
within the canopy. This early view shows the
memorial before the arrival of the statue.

THE ALBERT MEMORIAL,

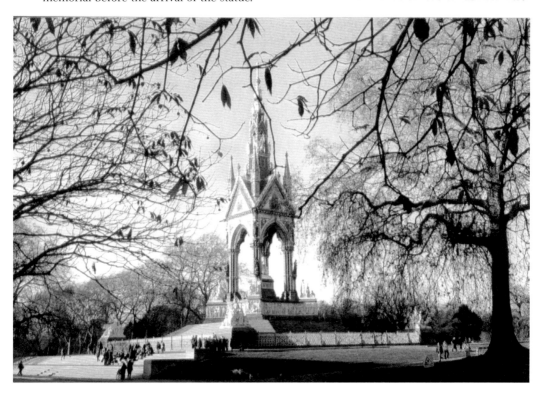

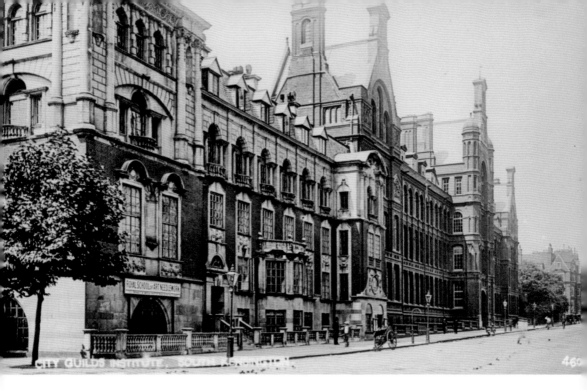

The Royal School of Art Needlework, Exhibition Road by Imperial Institute Road, _c._ 1905
This handsome building, faced in a colourful variety of materials, was a considerable adornment to the South Kensington townscape; it was designed by Fairfax B. Wade and was completed in 1903. In 1949, the school moved to Prince's Gate and the building was demolished in 1962 to make way for extensions to the Imperial College. The further part of the view is taken up with the City and Guilds College, whose buildings were designed by Alfred Waterhouse in rich red brick and terracotta. In 1962, the building suffered the same fate as its neighbour.

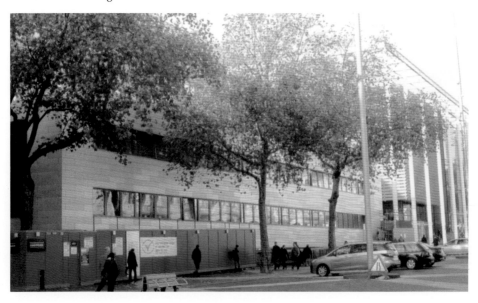

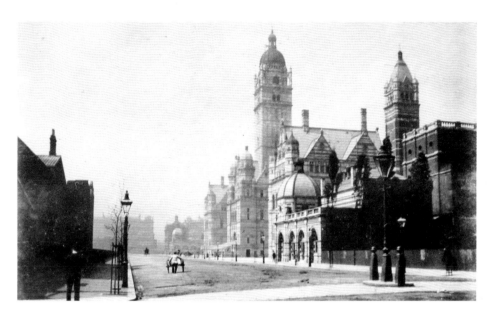

The Imperial Institute, *c.* 1895 and *c.* 1906

This mighty complex was designed by T. E. Collcutt and built between 1887 and 1893 as an exhibition showcase for the products of the British Empire and, among other things, to 'promote friendly intercourse among the inhabitants of the different parts of the Empire'. Styled 'The Commonwealth Institute' in later years, its display galleries were a popular part of South Kensington's treasury of museums. The Imperial College of Science, Technology and Medicine was established in 1907, the continued expansion of its campus bringing about the loss of the old institute, apart from its central tower, which remains as a reminder of past glories.

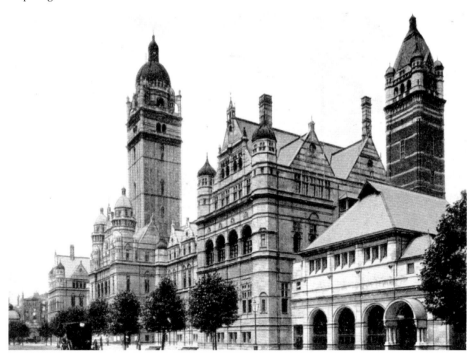

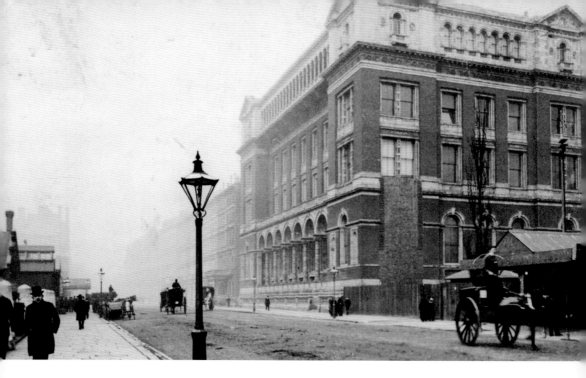

Exhibition Road, c. 1905

The dominant building here is the Royal College of Science (1872). It is now the Henry Cole Wing of the Victoria & Albert Museum (V&A). The V&A is one of the world's greatest museums of applied arts and was opened by King Edward Vll and Queen Alexandra in June 1909. Part of the museum's earlier manifestation as the South Kensington Museum (1857) is seen on the right before Sir Aston Webb's grandiose new building (1899–1909) in Cromwell Road provided a new side entrance here. The name 'Victoria & Albert' was adopted in 1899.

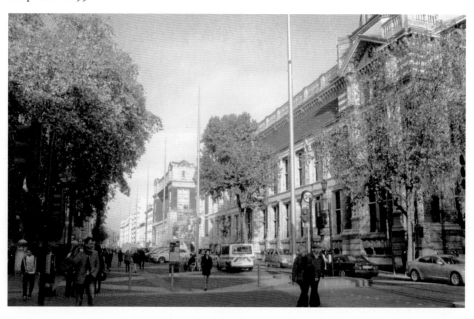

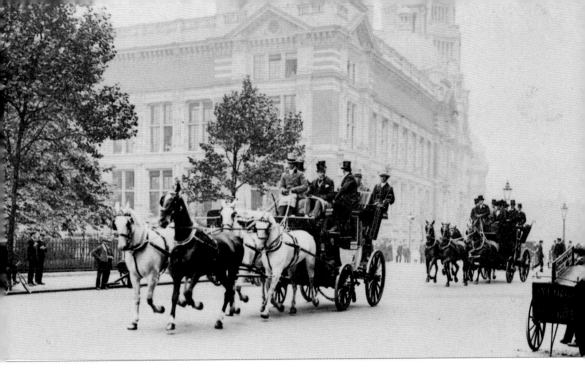

Coaching in Cromwell Road, *c. 1909*

With the motoring revolution gathering strength, coaching was in decline, but traditionalists still maintained old ways and coaches could still be hired in London into the 1920s. Here the coach parties (with everyone in a top hat), possibly on their way to the Epsom Derby, had attracted the attention of a local delivery boy (right). The backdrop is the newly built Victoria & Albert Museum, its pristine stonework as yet untainted by the smoky air of Edwardian London.

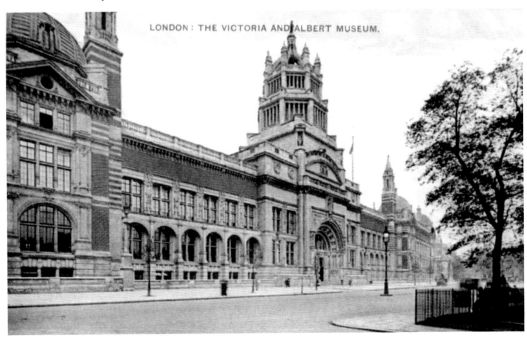

LONDON : THE VICTORIA AND ALBERT MUSEUM.

London Stereoscopic and Photographic Company.

The International Exhibition of 1862

This exhibition of art and industry was housed in a vast building that stretched from Exhibition Road to Queen's Gate. An astonishing variety of exhibits was on show, but the success of the earlier event in the Crystal Palace was not repeated, and its visitors sweltered in an overheated building during a hot London summer. Furthermore, the building was an object of ridicule – it remained open from May to October and was quickly removed afterwards, making way for the Natural History Museum.

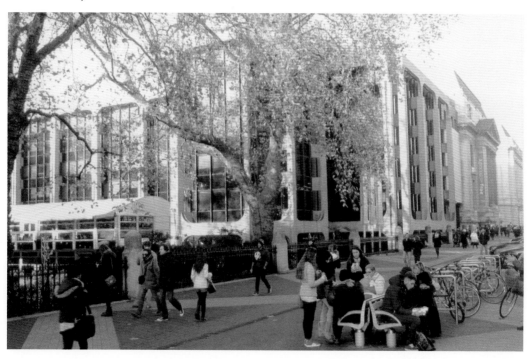

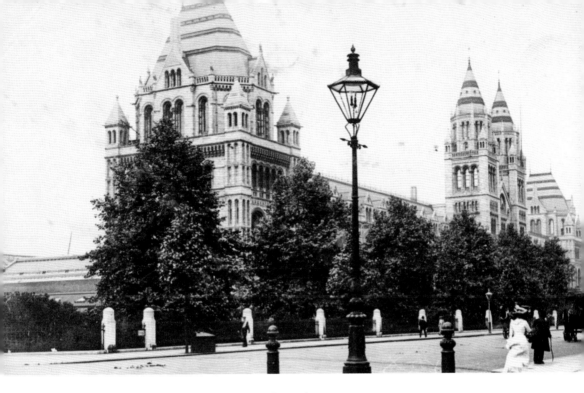

The Natural History Museum, Cromwell Road, *c.* 1903

When the International Exhibition of 1862 took place, Cromwell Road was in its infancy, having been laid out in 1855 as a new route from London to Earls Court. The exhibition's unrelentingly urban building was hastily removed and, in 1872, building began on Alfred Waterhouse's spectacular Natural History Museum. This housed the British Museum's natural history collections and opened in 1881. The effect of the fine architecture was enhanced by leafy gardens, in contrast to its predecessor, which rose straight up from the pavement.

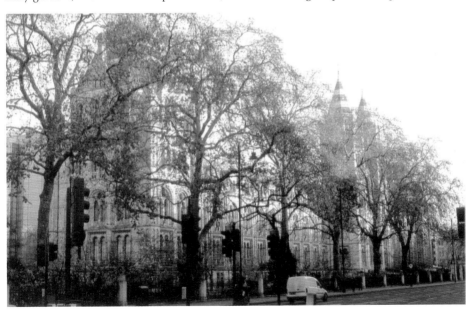

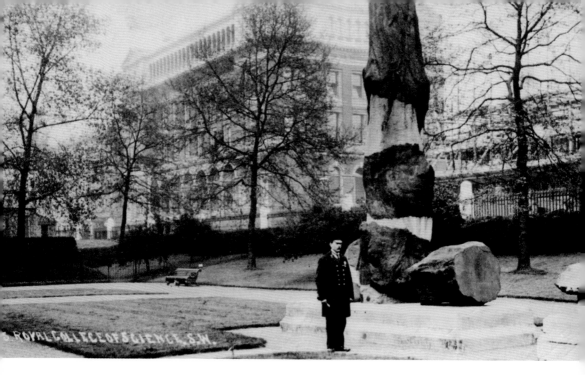

The Fossilised Tree, East Lawn, Natural History Museum, *c.* 1904
This ancient relic, long a feature of the museum's gardens, was recovered from rocks of the lower Carboniferous period (330 million years ago) at a quarry in Edinburgh and still retains part of its bark. It has been moved to a new site in the gardens. The old site is seen below hosting the museum's seasonal ice skating rink.

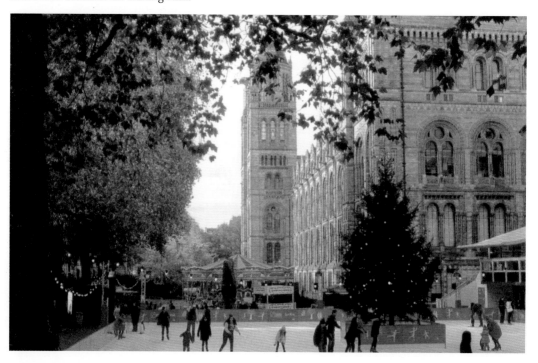

Exhibition Road, *c.* 1938

The buildings remain familiar to us, but part-pedestrianisation of the roadway has introduced a lively new world of pavement cafés and a vibrant street life. The iron and glass structures on the right gave light and ventilation to the subway that links South Kensington station to the museums. This first appeared in 1886 for the Inventions Exhibition, after which public access was denied until 1908.

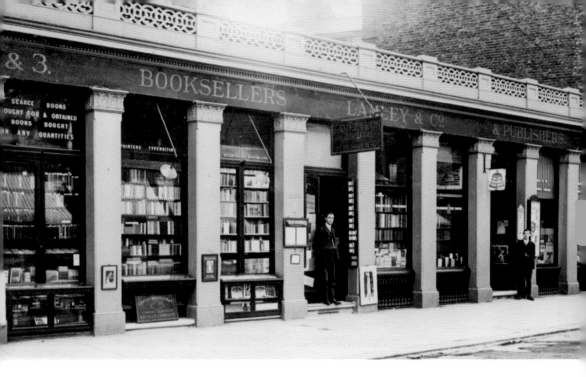

Lamley & Co., Nos 1–7 Exhibition Road, *c.* 1918
Bookseller, publisher, stationer and supplier of artists' materials, this renowned South Kensington institution was established in 1875. Lamley's also bought and sold antiquarian books and operated a lending library. Not surprisingly, the shop was a popular port of call for London's students. A rare single-storey building in Kensington, the premises now house a modern restaurant.

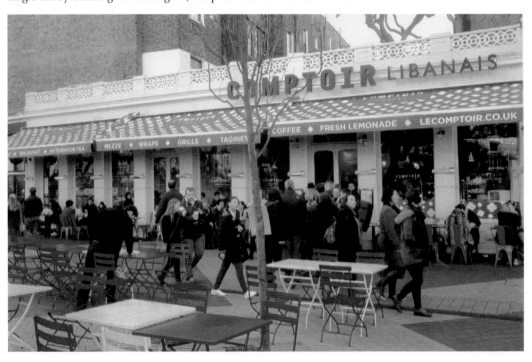

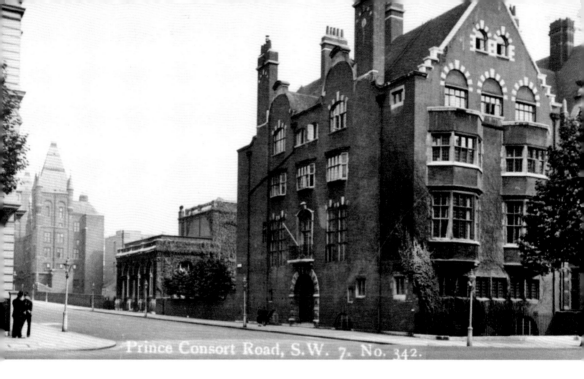

Prince Consort Road, S.W. 7. No. 342.

No. 185 Queen's Gate and Prince Consort Road, *c.* 1925
Among the last sites to be built on in Queen's Gate were those at the western extremity of the former Royal Horticultural Society's grounds. The new houses were grand in the extreme and were designed by the leading architects of the late Victorian era. No. 185 was by Norman Shaw and first occupied in 1892. The house was a Second World War casualty and the Imperial College's Blackett building later took over the site.

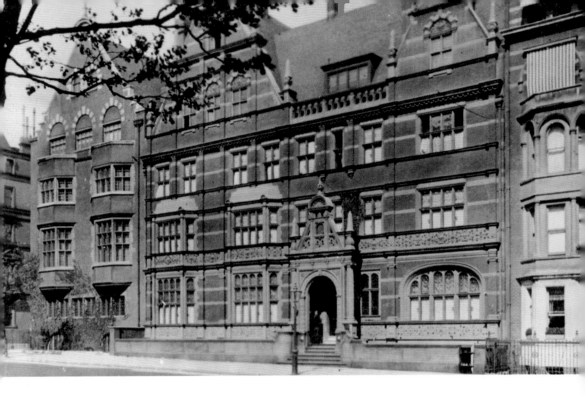

No. 184 Queen's Gate, c. 1909
This grand mansion had one of the widest frontages of a terraced house in London – it was built in 1894/95 for George M'Culloch, a Scotsman who had made his fortune in the Australian goldfields. This fine house, with its rich red brick and terracotta, survived until 1971 when, disgracefully, it was demolished for another of the Imperial College's functional blocks.

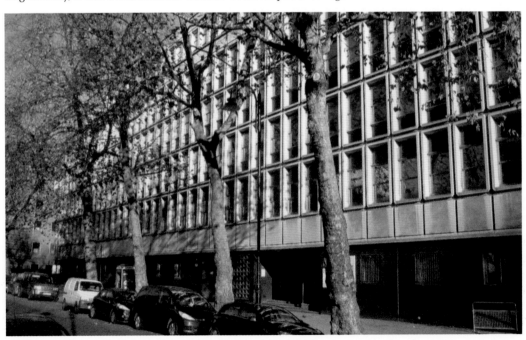

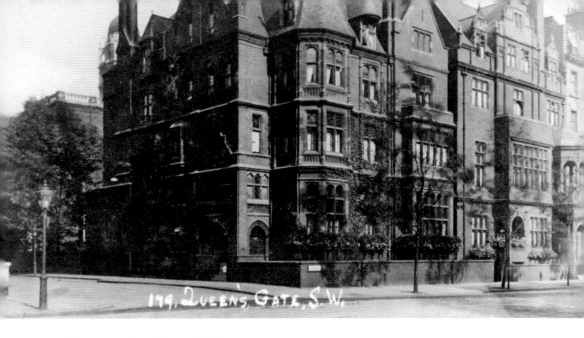

Nos 179 and 178 Queen's Gate, *c.* 1910

A pair of noble town mansions designed by William Emerson in fine red brick with red-stone dressings. They were built from 1889 to 1891 for a pair of wealthy Anglo-Indian gentlemen – the Indian connection extended to their architect who had designed Allahabad Cathedral. The opening on the left led to a former home of the Science Museum, but all was destroyed in 1971 for further college extensions.

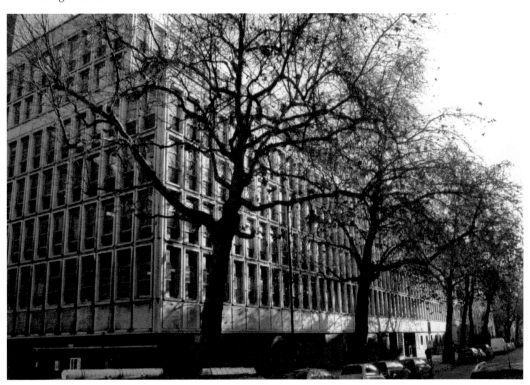

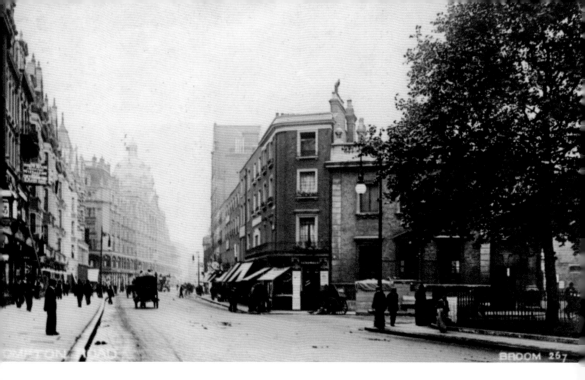

Brompton Road from Knightsbridge Green, c. 1905

Now one of London's fashionable shopping streets, this originated as a rural route from the capital to Brompton village. It lost its rural look with early ribbon development, but the buildings were modest in nature at first. By Edwardian days, Brompton Road's fortunes were on the rise, led by an opulent rebuilding of Harrods department store. The shopping terrace on the right dated from the 1820s, but it was replaced in 1957 by the concrete horror that was Caltex House. However, a more appealing look prevails today. Tattersalls, the horse auctioneers were here until 1939 (right).

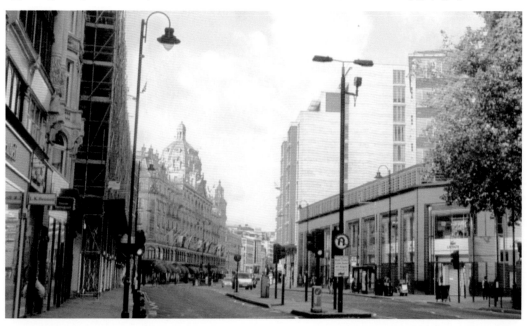

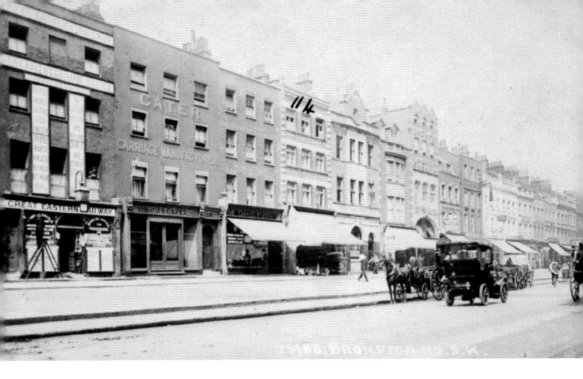

Brompton Road, *c.* 1905

Around 1766, two long terraces called Biscoe's Building arose along the semi-rural Brompton Road; a renaming 'Brompton Row' quickly followed. Wide stepped pavements protected the shoppers from muddy splashes from the road, but these and many of the buildings were eroded during the decades that followed. A flavour of the early days remain with a handful of original buildings.

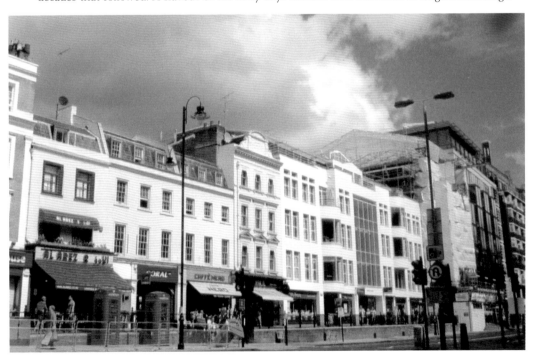

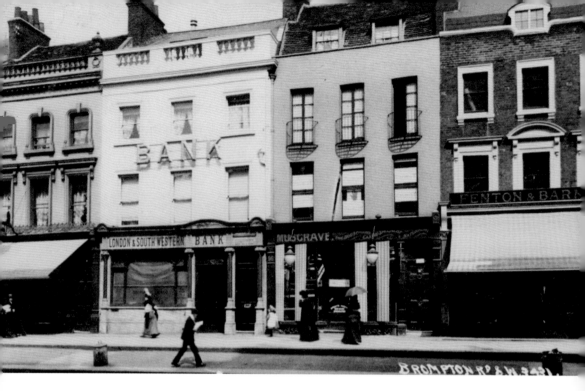

Nos 94–100 Brompton Road, c. 1905
A closer look at a quartet of Brompton Row's original buildings as they appeared in Edwardian days. The shops included those of M. Musgrave, bird and animal dealer; Fenton & Barnes, ironmongers; and the London & South Western Bank. Fashionable apartment blocks have since transformed the view; Prince's Court (right) came in 1934.

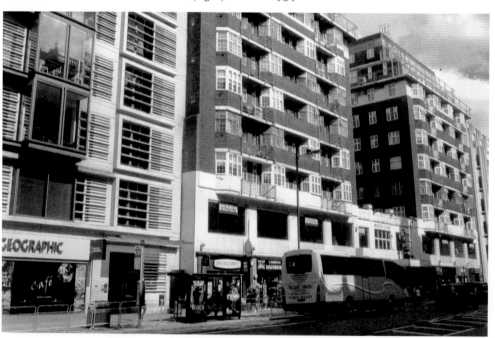

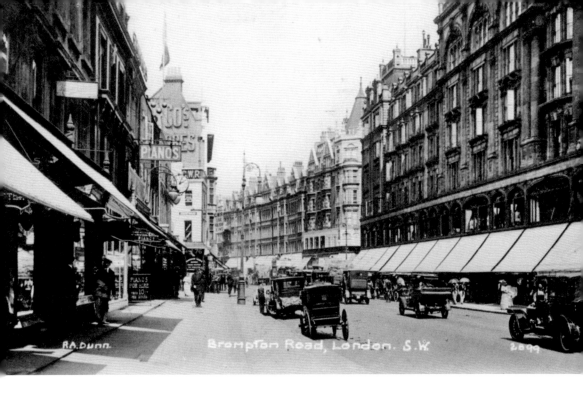

Harrods, Brompton Road, c. 1914

Grocer Charles Henry Harrod opened his first small shop in an unfashionable Brompton Road in 1848. The business prospered and expanded, and from 1902 Mr Harrod's world-famous terracotta palace of retailing arose on the site of the original. Harrods is famous for its window displays, shielded here by an array of sun blinds, while the wide pavement has yet to be cut back for road widening.

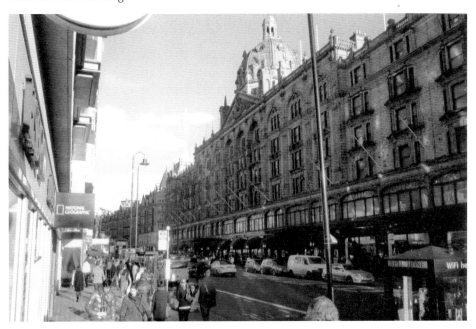

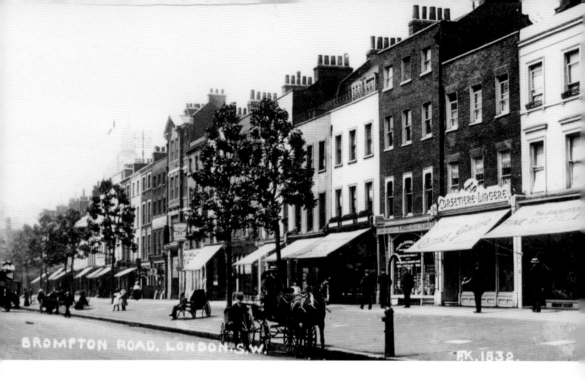

Brompton Road West from Montpelier Street, *c.* 1904
The westernmost of the pair of terraces that formerly made up Brompton Row. Several of the plain brick frontages remain, but too many individual premises have been altered or rebuilt. Shops seen here include the Brompton Fine Art Gallery, an early indication of the trend towards smart shopping here in Edwardian times.

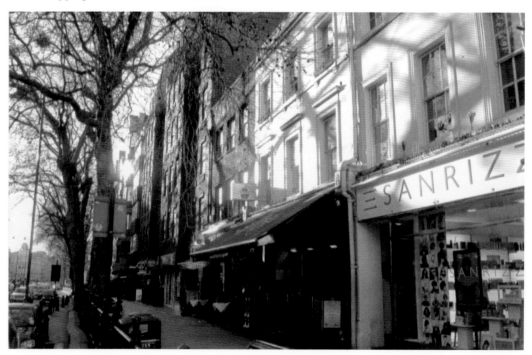

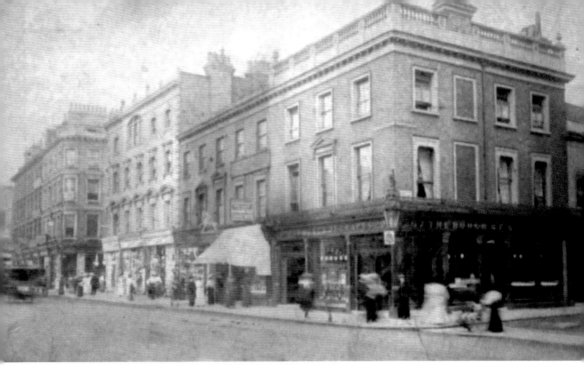

The Bunch of Grapes, Brompton Road by Yeoman's Row, *c.* 1906
An 1845 rebuilding of an old country inn, the Bunch of Grapes is the last of Brompton Road's pubs to survive into the present day. Its setting changed further in 1930, when Ovington Court replaced neighbouring premises, including a one-time entrance to Harrods livery stables.

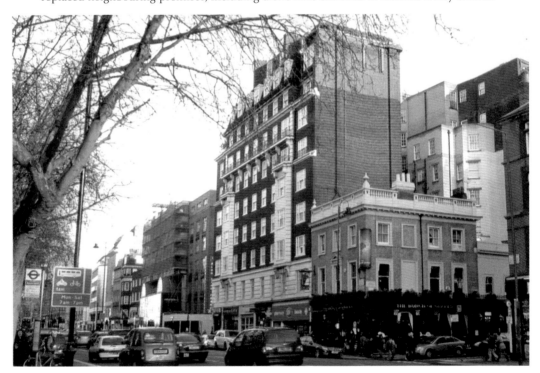

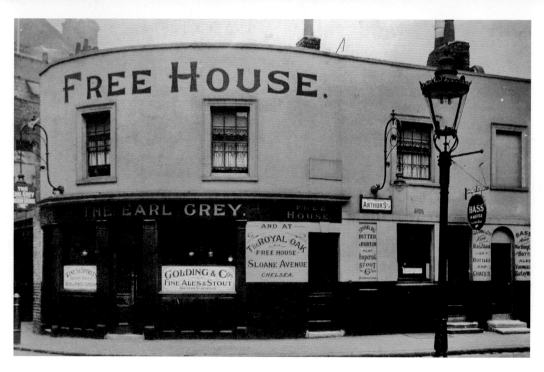

The Earl Grey, Arthur Street (Trevor Place), From Lancelot Place, c. 1908
Located just behind Brompton Road, this long-lost pub once served a clientele of coachmen, cab drivers and residents from its local neighbourhood of picturesque cottages and modest terraces. As the twentieth century advanced, the area rose rapidly up the social scale with the apartments of Prince's Court arriving in 1934 and smart modern houses in place of Lancelot Place's rustic dwellings. (*Courtesy Maurice Friedman*)

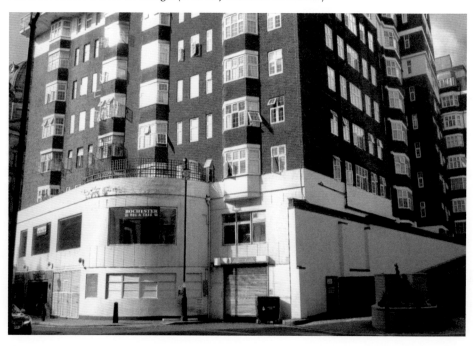

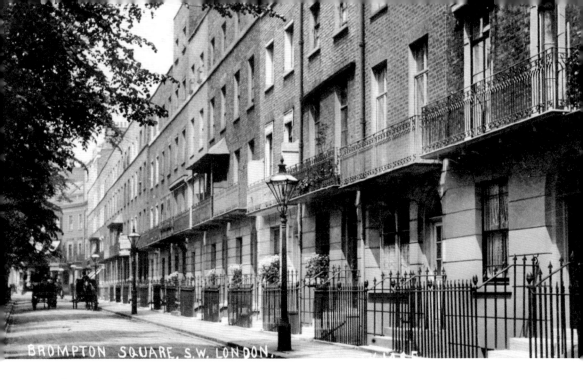

Brompton Square, *c.* 1904

The building of Brompton Square in 1821 gave the area an early taste of life in an upmarket London square, a particular characteristic of South Kensington. As with many such streets hereabouts, the townscape has been lovingly preserved with modern versions of the Victorian gas lamps maintaining the ambience. The square is made up by a pair of matching terraces linked by a small crescent from the 1830s.

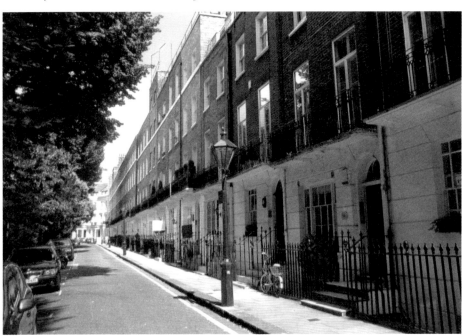

29

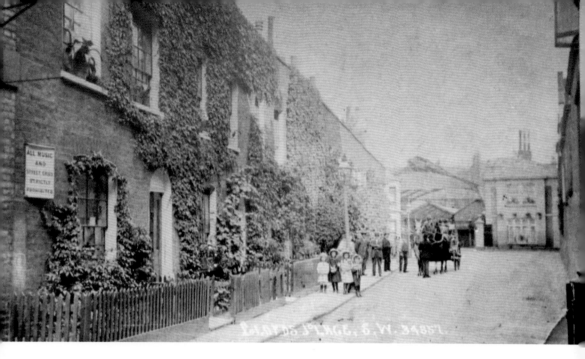

Lloyd's Place (Brompton Place), *c.* 1906

Some of Brompton Road's tributaries retain tantalising reminders of the days when this area was at the semi-rural western fringe of London. When these cottages were built (1825–32), their residents enjoyed an outlook over open countryside before the large-scale building projects of the new South Kensington hemmed them in. The end of the cul-de-sac was once taken up by the Beaufort Riding School and livery stables. Harrods car park is there now.

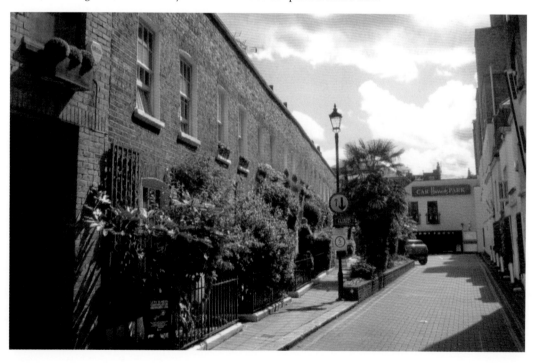

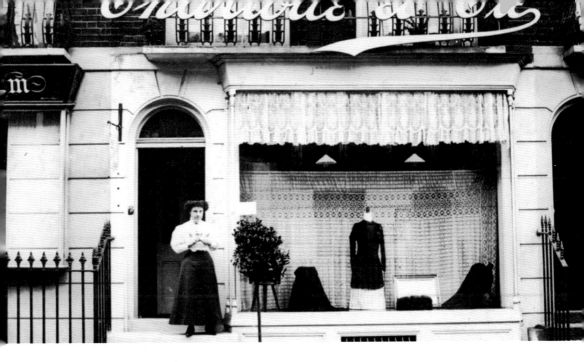

No. 40 Beauchamp Place, c. 1908
The street was built up from 1820 as residential Grove Place, a name it retained until 1885, by which time several of the plain town houses were beginning their transformation into shops. This process continued through the Edwardian era, and soon Beauchamp Place was lined with the smart shops and restaurants for which it remains famous. Charlotte et Cie at No. 40 were dressmakers.

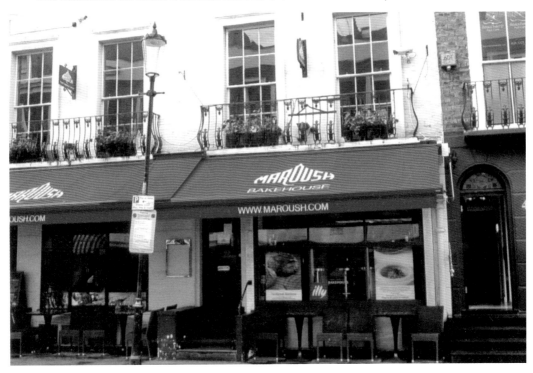

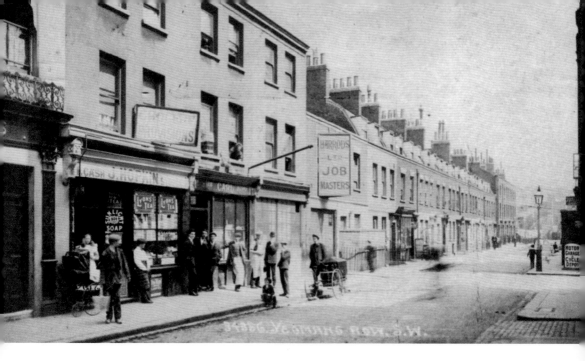

Yeoman's Row from Brompton Road, c. 1905

Here John Hopkins' grocery shop has attracted some interest in a side street of houses dating from 1766–71; the more distant ones still stand. The centre of the view shows another aspect of Harrods: the stables where the company acted as jobmasters. Much changed here in the 1960s when the older houses were replaced by modern, neo-Georgian ones.

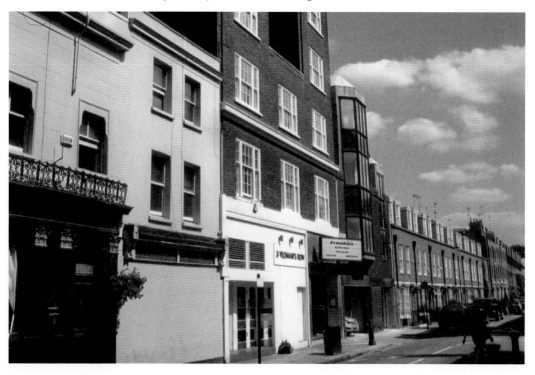

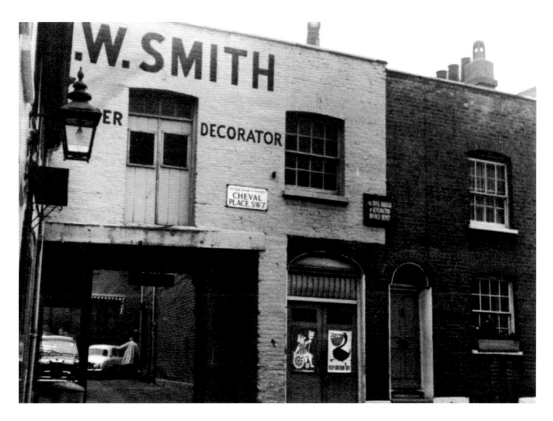

Cheval Place, *c.* 1964

The hand of the gentrifier has given this quaint corner of Brompton Road's hinterland a bright new look. In a street once called Chapel Place, these premises were home to A. W. Smith, the builders, and in Victorian times, a saddler operated from the stables through the archway. A blue enamel sign pinpoints the location of a former council stores and cleansing depot.

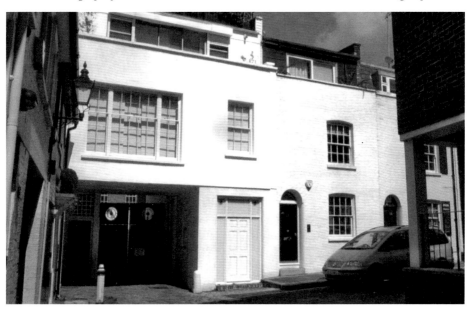

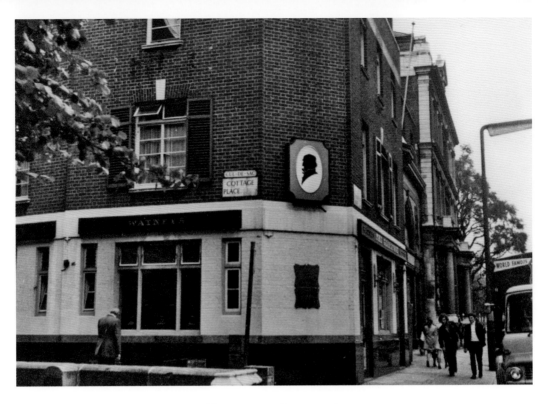

The Gladstone, Brompton Road by Cottage Place, *c.* 1969

The Gladstone was an old Brompton Road pub, rebuilt in the twentieth century but a casualty of road widening in the 1970s. Beyond it is part of Brompton Road station, a stop on the Piccadilly Tube; it served from 1906 to 1934, after which the redundant building lingered on. Only the station's façade in Cottage Place remains visible today.

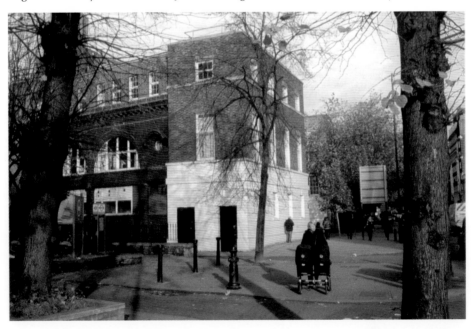

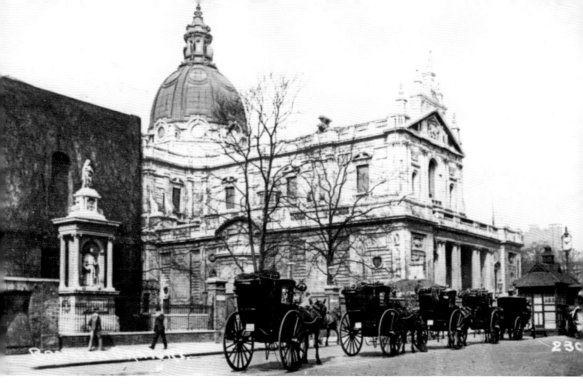

The Oratory of St Philip Neri (Brompton Oratory), *c.* **1904**
Consecrated in 1884, Brompton Oratory arose on the site of an oratory house set up in 1852 for an order of secular priests. The opulent, cathedral-like new oratory, London's most spectacular Roman Catholic church, was built to the designs of Herbert Gribble; the dome and façade were later embellishments. Also seen here is the monument to Cardinal Newman, put up in 1896. The cab rank in front of the oratory endured for many decades, but has since been relocated off-camera (left).

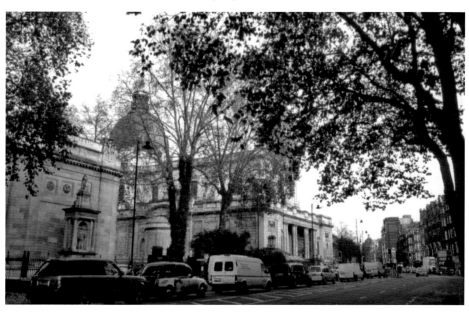

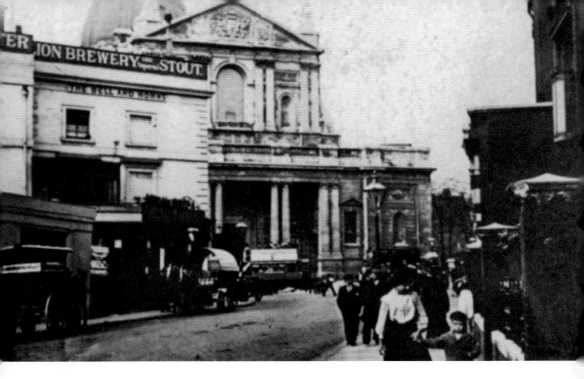

Brompton Oratory from Fulham Road, c. 1907

The view of the Oratory is partly obscured by the Bell & Horns, a hostelry from around 1772. It was a landmark at the meeting point of two highways, Fulham Road and Thurloe Place leading to Cromwell Road. The beginning of the end for the old pub commenced in 1910, when the first part of Empire House was built behind and at the side of it, but it was not until 1916 that the old landmark finally succumbed and the final part of Empire House was completed. Street widening also opened out the vista of the oratory, which we see today.

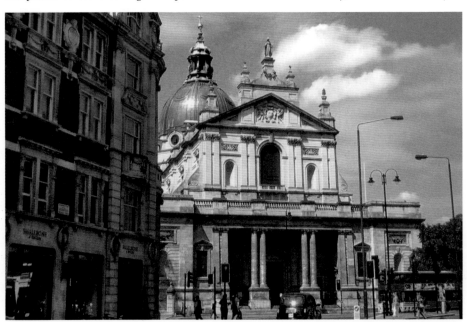

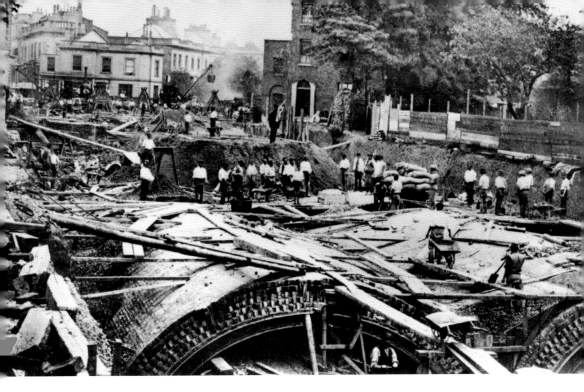

Building the Metropolitan Underground Railway, Cromwell Lane (Harrington Road), 1860s
A key stage in the transformation of Brompton into South Kensington came in 1868, when it was connected to the London Underground railways. This was preceded by the massive excavations seen here at what would later become Harrington Road. Distant Pelham House gave its site for South Kensington station, and Harrington Road was laid out above the tunnels once they had been covered over. (*Photograph copyright of TfL, from the London Transport Museum Collection*)

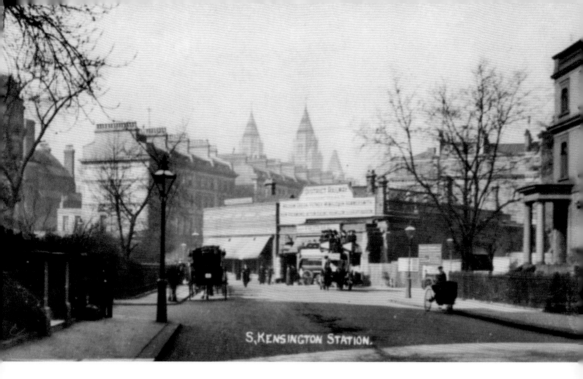

S. KENSINGTON STATION.

South Kensington Station, c. 1905 and c. 1908

The original name of the station was to have been 'Brompton Exchange', but the name of an emerging quarter of London was preferred. Contrasting images here show the remains of the original brick-built station, and the later part that was opened for the Great Northern, Piccadilly & Brompton Railway (Piccadilly Line) in 1907. This served a new generation of deep-level electric lines, and the Leslie Green-designed street entrance with its ox-blood tiles was a vivid architectural statement amid South Kensington's sober brick and stucco.

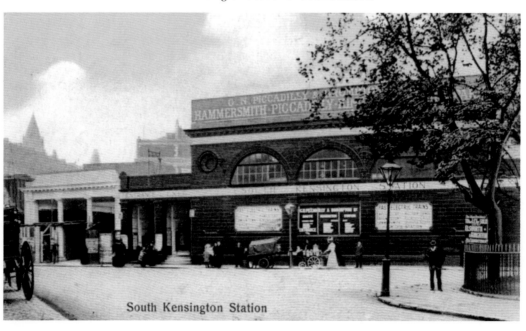

South Kensington Station

Harrington Road from South Kensington Station, *c.* 1907
With the Underground's tunnels covered over once more, building began on a new street, Harrington Road, along the line of the old Cromwell Lane. The Norfolk Hotel (since renamed) arose in 1889, as did the row of residential chambers beyond.

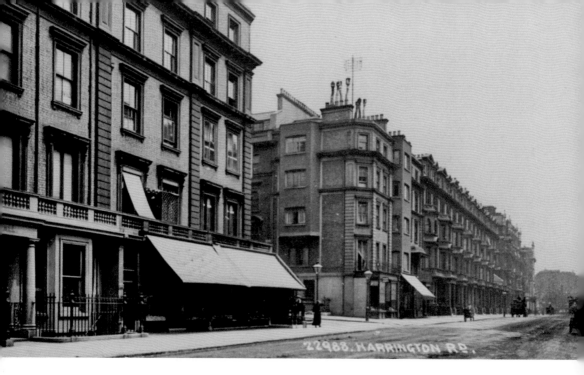

Harrington Road by Queensberry Place, c. 1906
The Second World War seriously damaged this row of bay-windowed houses, which were used as residential chambers. The long-empty site was filled between 1982 and 1984 with a block of classrooms for the Lycée Français, the French Institute, strengthening South Kensington's long-standing French community.

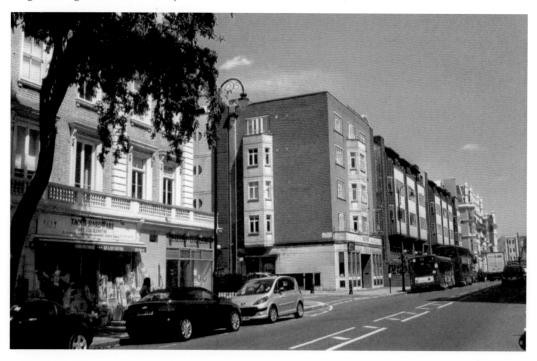

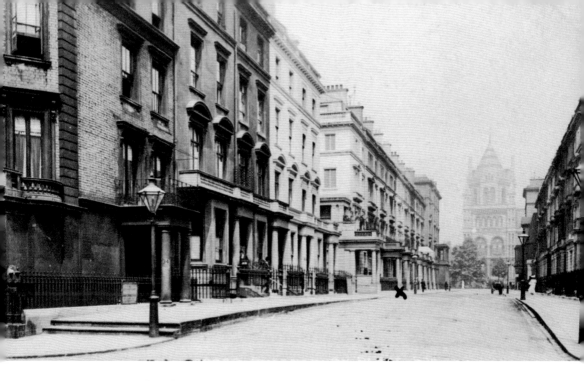

Queensberry Place from Harrington Road, c. 1907
The street's first houses were built in 1862, the year of the International Exhibition, whose grim walls gave a poor outlook for the first residents here. In this view, the street has retained its full complement of town houses, but in 1935 work began on P. Bonnet's remarkable Institut Français at the corner of Queensberry Mews East (Queensberry Way). The school had previously been housed in Cromwell Gardens. More houses here were taken over as the school expanded further in the 1980s.

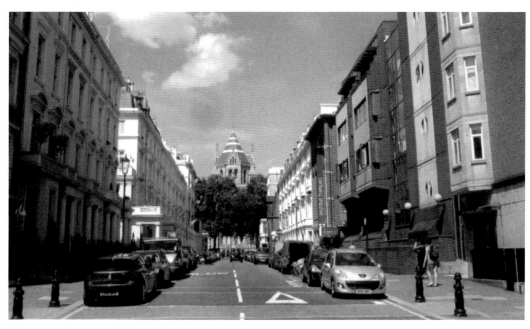

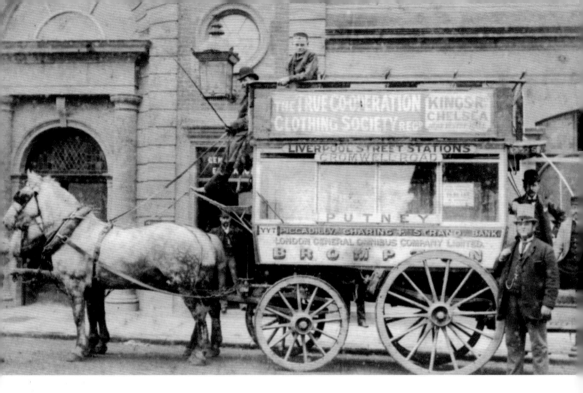

The Brompton Omnibus, _c._ 1890

With its multiple Underground lines, converging roads and array of bus services, South Kensington station has long been a focal point of life in the area. Several of today's bus services tend to follow similar routes as their horse bus ancestors, like this one that was operated by the London General Omnibus Company. The journey was from Putney via the West End to the City, taking in much of the modern route 14.

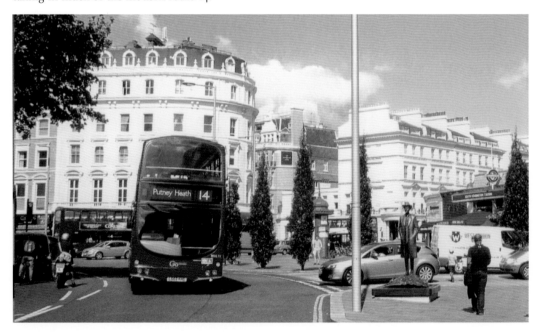

Onslow Crescent, c. 1906

The gently curving Onslow Crescent was built from 1851–56 and lasted until 1937, when the flats and shops of Melton Court were put up. The old crescent's garden did not give up easily, however, and parts of it lasted into the 2000s, when the last of it was finally swept away to meet the demands of modern traffic.

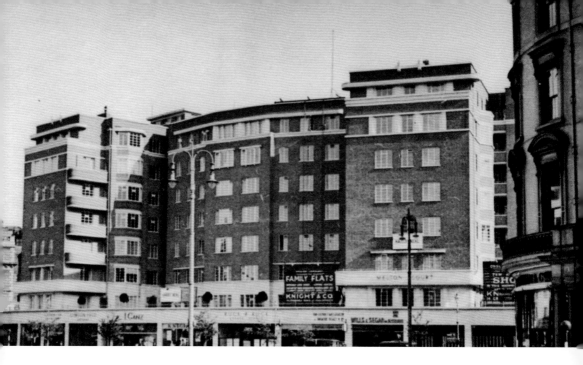

Melton Court, Onslow Crescent, 1938
It is 1938 and this handsome block of 'family flats' has been completed and is ready for occupation. There are also new shops and those already occupied feature long-famous South Kensington businesses including Ruck & Ruck, estate agent's, and Wills & Segar, florist's, who had previously inhabited a large glass conservatory on part of the site of the flats.

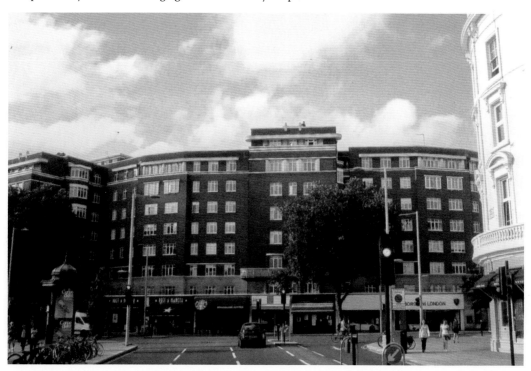

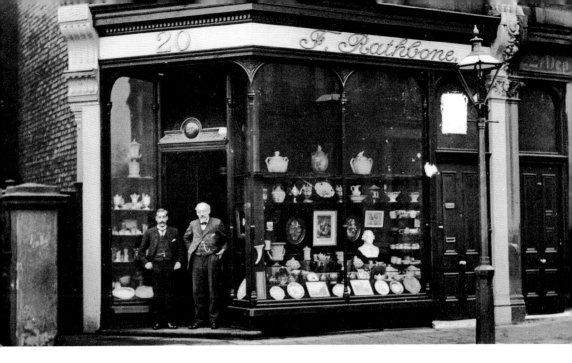

Frederick Rathbone, Wedgwood Dealer, No. 20 Alfred Place West (Thurloe Street), *c.* 1907
This is one of a row of shops built following the opening of the adjacent South Kensington station – the first of the shops was occupied in 1882. No. 20 is seen when it served as a collectors' shop for devotees of Josiah Wedgwood's celebrated products. From 1947, the shop has housed Daquise, a restaurant specialising in Polish cuisine. Polish film director Roman Polanski frequented Daquise for a taste of his homeland during the shooting of *Repulsion*, a film in which location spotters could savour atmospheric scenes of mid-1960s South Kensington.

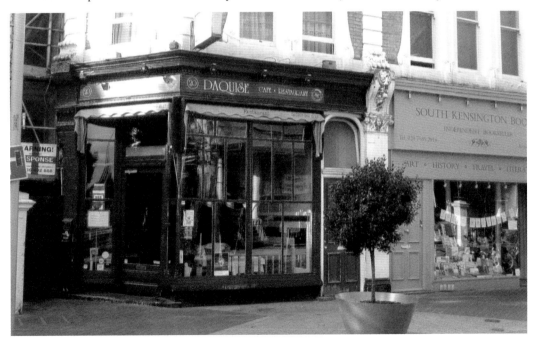

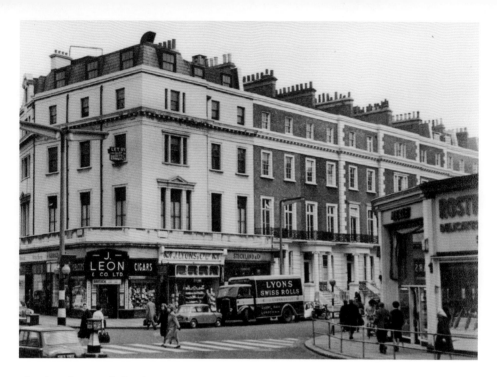

Thurloe Place and Thurloe Street, 1962

This corner was marked by a trio of shops that served South Kensington well through
many decades. Leon, the tobacconist, had the corner and, next door, a branch of J. Lyons
was a popular amenity alongside Stickland & Co., chemist's. The old Lyons bread shop is
now the location of Boujis, a nightspot that has been popular for more than a decade with
partying socialites and royalty.

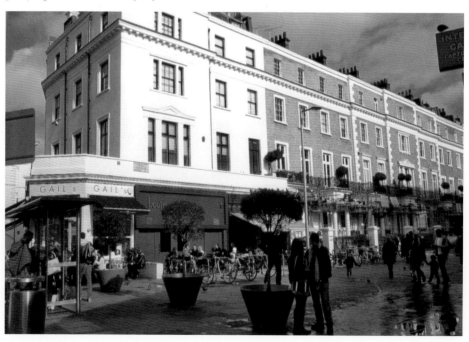

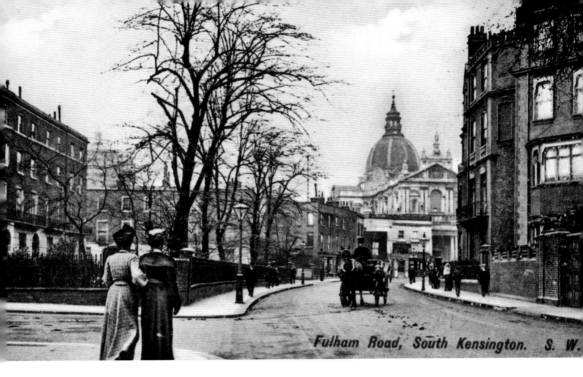

Fulham Road, South Kensington. S. W.

Fulham Road from Alexander Square, *c.* 1906
The old road to the one-time village of Fulham merged with Brompton Road by Brompton Oratory, which is distantly seen here. On the left is Alexander Square, which dates from the 1820s and '30s, representing an earlier style of housing locally.

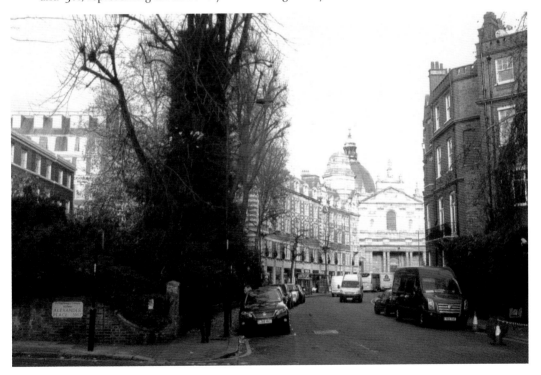

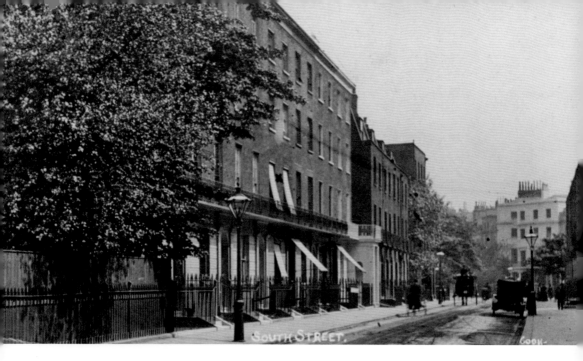

South Street (South Terrace), *c.* 1906

The houses were built around 1832, an early year in South Kensington's emergence as a new residential area of London. The houses were still in the Georgian tradition, with plain brick-fronts and little ornamentation. The cream-painted Italianate style so typical of the area was yet to arrive.

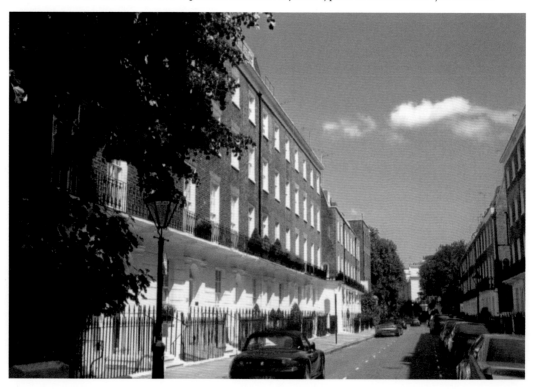

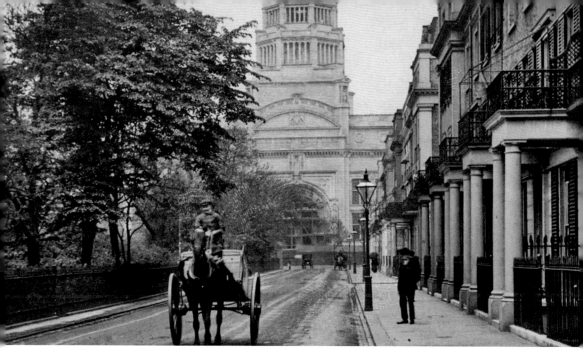

Thurloe Square from South Street (South Terrace), *c.* 1906
By the 1840s, when this square was built, new houses adopted the fashionable Italianate style of big columned porches and stuccoed façades. The concept of tall, terraced houses overlooking leafy garden squares was also gathering strength; Thurloe Square was a classic example. Here, the Victoria & Albert Museum provides a fine backdrop as its final building works take place.

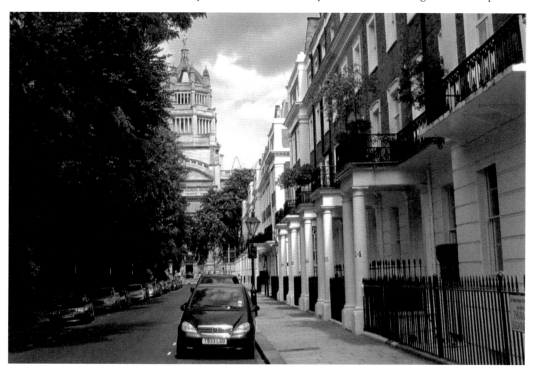

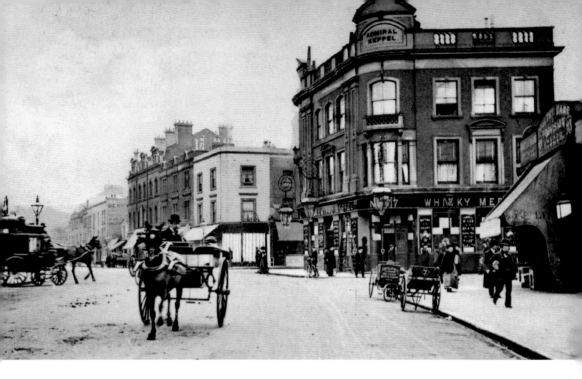

Fulham Road by Keppel Street (Sloane Avenue), c. 1906
The Admiral Keppel pub commanded a prominent site with Marlborough Road (Draycott Avenue) seen further on. The pub was rebuilt in 1856 as the area became urbanised; it had previously been a rustic inn and tea gardens. The modest shops on the right would shortly make way for Bibendum House (1909–11), a remarkable creation for the Michelin Tyre Co., complete with stained glasswork and panels depicting early motor racing scenes.

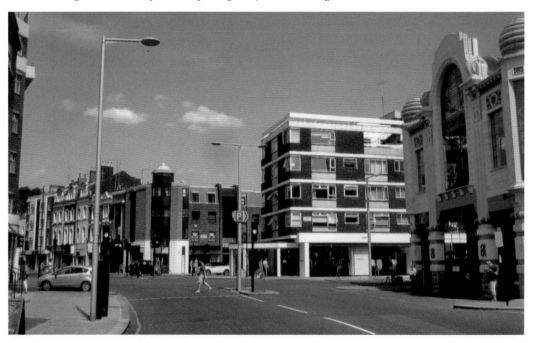

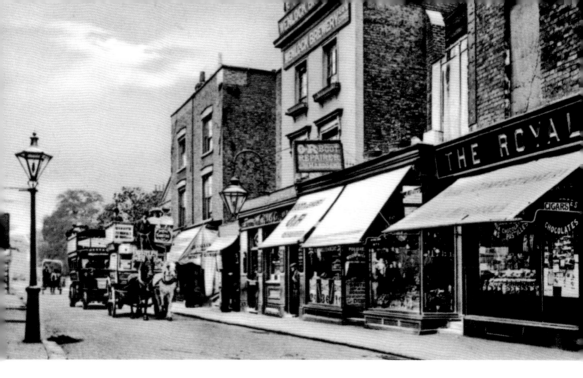

Pelham Street from Fulham Road, *c.* 1906

The long-forgotten Pelham Arms is flanked by local shops, including those of Alfred Barns, second-hand bookseller; a bootmaker; and, on the Fulham Road corner, the former Royal Chandos Cycle Co., seen here after a confectioner had taken over the shop. Despite its narrowness, Pelham Street was a busy bus route, but everything changed when the Kensington & Knightsbridge Electric Co. built new premises in 1924.

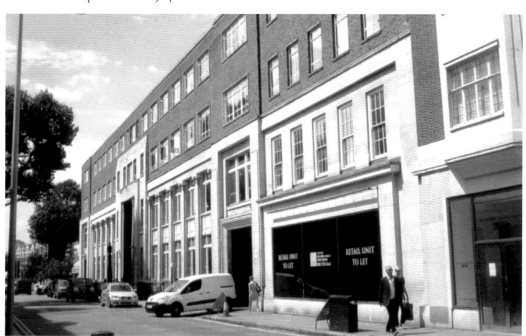

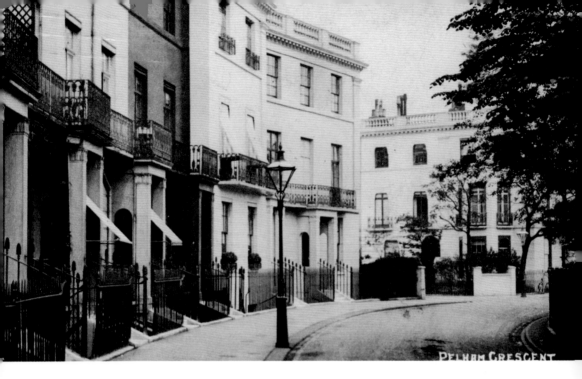

Pelham Crescent, Fulham Road, *c.* 1905

This is part of an elegant neighbourhood of stuccoed Regency-style houses, built by George Basevi in 1833 on former nursery gardens. This was part of the Smith's Charity Estate, of which Henry Thomas Pelham, Earl of Chichester, was a trustee. His name lives on in the street.

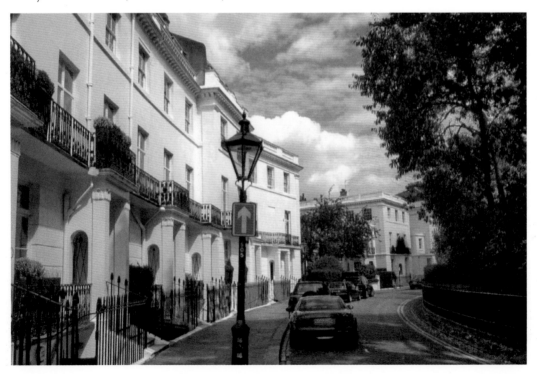

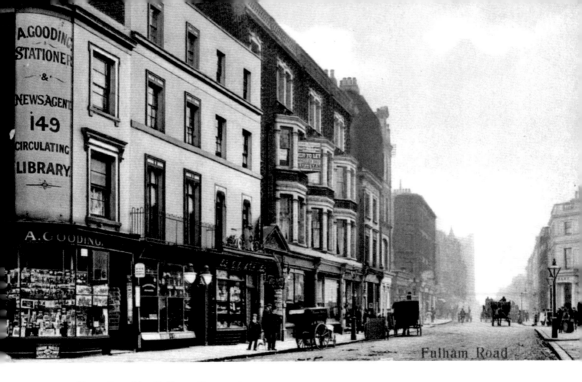

Fulham Road by Pelham Crescent, c. 1907

This road once separated the old Kensington and Chelsea boroughs, before they were united as the Royal Borough of Kensington & Chelsea in 1965. On the Chelsea side (left), old shops with living space above were replaced in the 1930s by the residential blocks of Thurloe and Pelham Courts. Before that, Alice Gooding's corner shop offered stationery, newspapers and operated a circulating library.

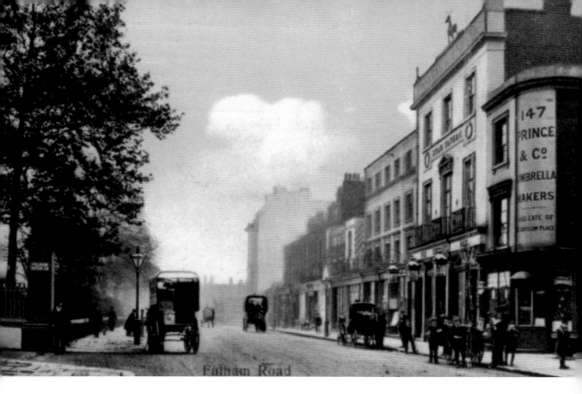

Fulham Road by Pelham Crescent, *c.* **1907**
A further look at this much altered row with Prince & Co., umbrella makers, standing next to the long-lost Stag Tavern, complete with a representation of that noble beast adorning the rooftop. Also here but a little further down was the South Kensington Photographic Studio.

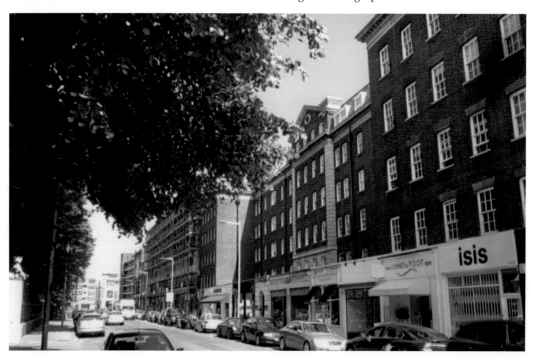

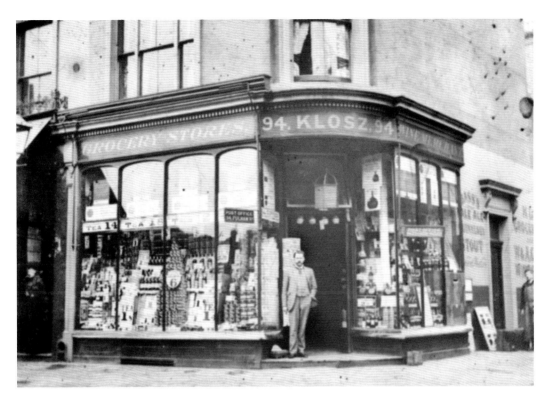

No. 94 Fulham Road by Neville Street, *c.* 1906
William Klosz's grocery shop shared its premises with a post and telegraph office, a once common arrangement that ensured that most shopping streets had a post office. In later years, this became a branch of the popular grocery chain, Oakeshots Ltd.

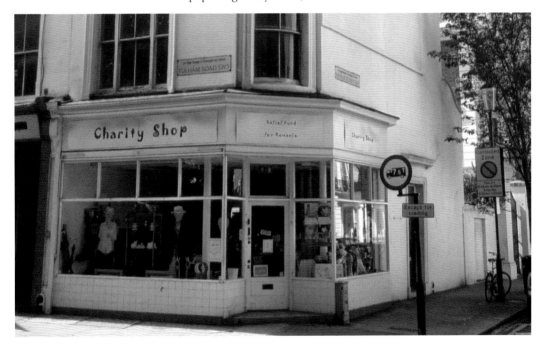

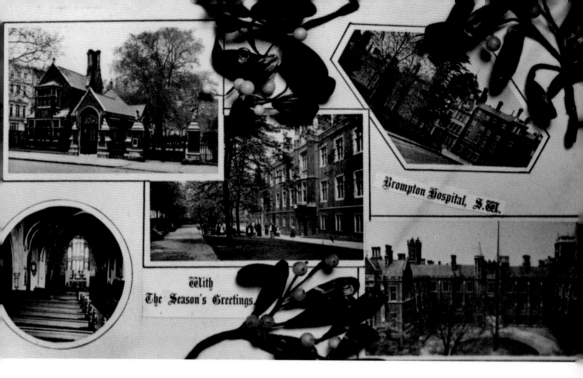

Brompton Hospital, Fulham Road, *c.* 1910

Built from 1844 to 1846, this was the first hospital in Britain to be built for the treatment of consumption; its site in Brompton was specially chosen for the high quality of its air. Progressively enlarged, it became the Royal Brompton National Heart and Lung Hospital, but it moved away to a new site in Sydney Street in 1991. The glorious, Tudor-style buildings then took on a new role as an upmarket residential complex and a new address, Rose Square.

Onslow Baptist Chapel, Neville Terrace, Fulham Road, c. 1905

Designed by W. Mumford for a local nonconformist congregation and attractively faced in Kent ragstone and Bath stone, this small place of worship opened in 1856. The chapel remained in use until after the Second World War, but after a period of neglect, it was demolished in 1961. The chapel stood at the end of a row of houses, and once the site was cleared, new houses were built that splendidly matched the neighbouring originals.

Elm Place from Fulham Road, c. 1890
A residential street built in the 1820s, where market gardens once stood. The street has been gentrified and well preserved. To the right, a new entrance to Lecky Street was created with the Regency Terrace development of 1960–64.

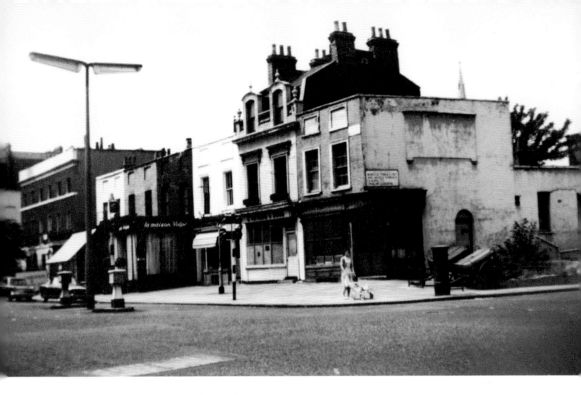

Nos 110–126 Fulham Road, *c.* 1961

These ageing properties arose with ribbon development along Fulham Road in the days when this was still a semi-rural area. A mixture of dairymen, builders, electricians and a picture frame maker were still trading here as the properties approached their demise. The taller houses at the far end of the row are by Lecky Street, which then had a direct link with Fulham Road. This was a characterful corner of South Kensington, but it was sanitised by the building of Regency Terrace in the 1960s.

Drayton Gardens, *c.* 1906

South Kensington's residential streets generally run in straight lines, but those with a more meandering course hint at their rural origins. Drayton Gardens was once a rustic lane running past country houses and market gardens, with suburban villas springing up early in the 1800s. A few of the old houses remain, but a fashion for mansion flats and modern apartments removed some of them, as here with Onslow Court (1935) and Drayton Court (1902).

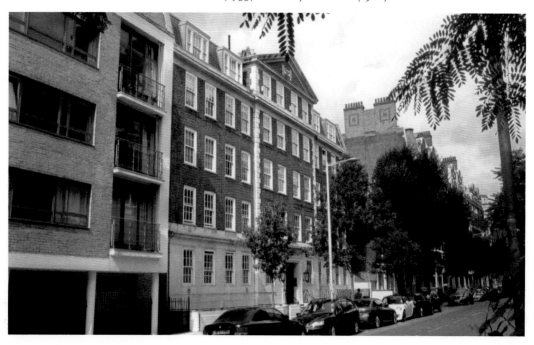

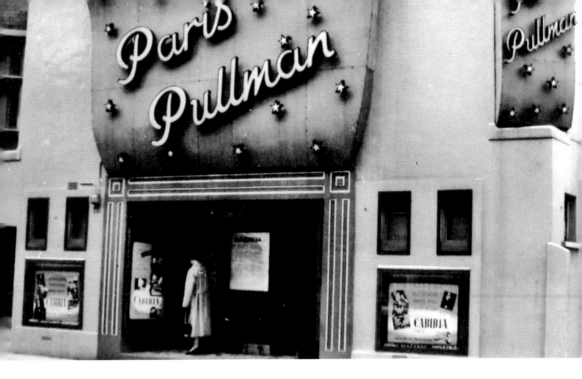

The Paris Pullman, No. 65 Drayton Gardens, 1958
Many of the earliest cinemas were merely conversions of existing buildings. In 1911, the South Kensington Gymnasium embarked on a new venture that embraced the burgeoning craze for viewing 'moving pictures'. Reborn as the Radium Picture Playhouse, it introduced local people to the delights of moviegoing and, in a long life, evolved as the Boltons Cinema, and with live shows, as the Boltons Theatre. In 1955, a revamp brought the Paris Pullman, a luxurious (albeit overheated) art house cinema, which endured until 1983. (*Courtesy Maurice Friedman*)

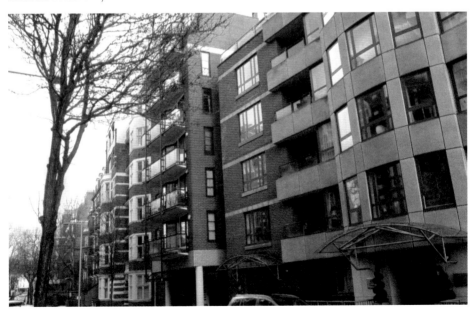

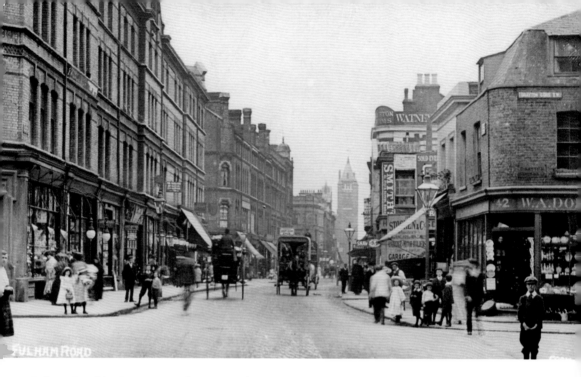

Fulham Road by Drayton Gardens, *c.* 1906
South Kensington had to wait until 1930 for its first, and only, super-cinema, the Forum, later the ABC. Designed by J. Stanley Beard, it replaced a group of modest properties, including William Dolling's china and glass shop, and Stocken & Co., carriage and motor builders.

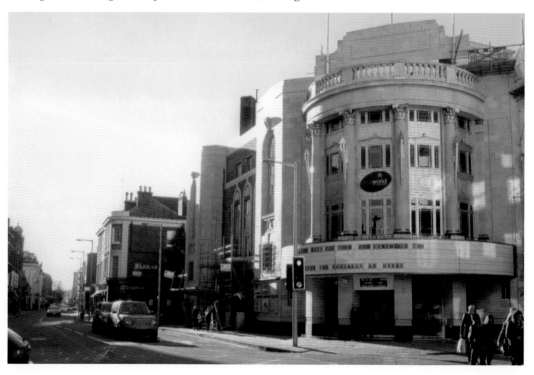

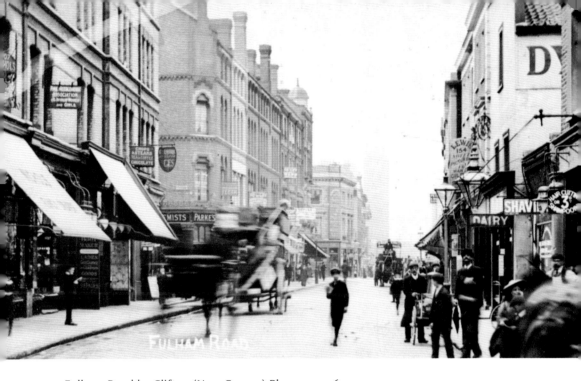

Fulham Road by Clifton (Now Cavaye) Place, *c.* 1906
More of Fulham Road's narrowest section with its small shops on the right, including those of William Butler, hairdresser ('Haircutting & Shampooing 3*d*'); Hill & Tyne, dairymen; and Louis Lewis, picture frame maker. An old pantiled roof recalls a once common local style.

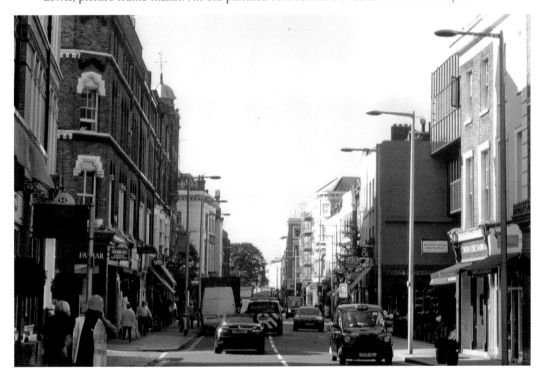

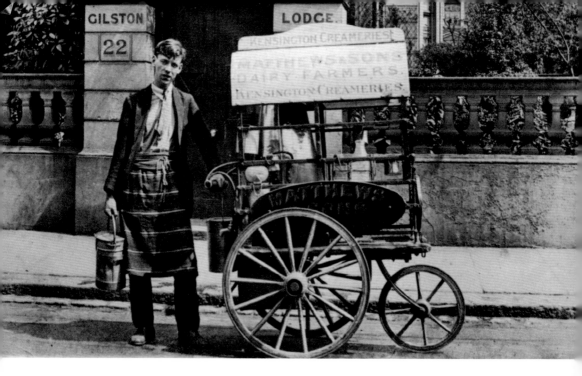

The Milk Round, Gilston Road, c. 1906
The milk cart and delivery boy came from Matthews & Son's Dairy Farmers in Fulham Road. This was a time when bottled milk was rarely seen, clients supplied their own receptacles, which the milkman would fill from a churn on the handcart. Gilston Road remains a street of large houses put up around 1852.

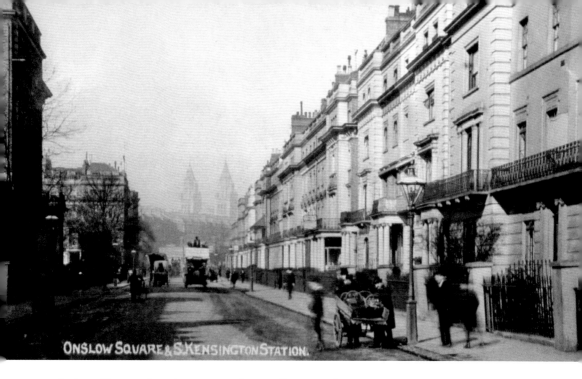

ONSLOW SQUARE & S.KENSINGTON STATION.

Sydney Place and Onslow Square from Fulham Road, *c. 1906*
Sydney Place leads on to Onslow Square, the houses of which were designed by Sir Charles Freake in the 1840s. Several houses here were destroyed during the Second World War, but their replacements were fronted by replica façades preserving the integrity of the design. The skyline is marked by the towers of the Natural History Museum.

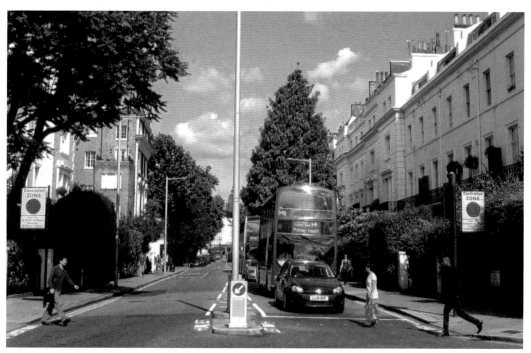

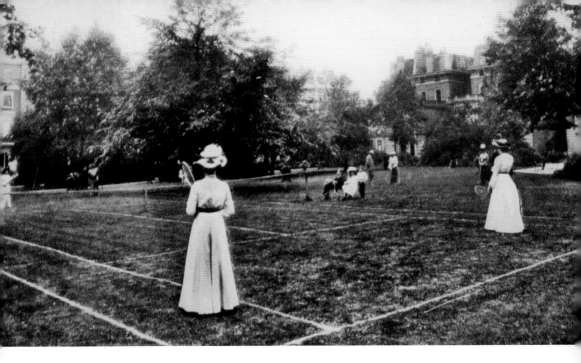

Lawn Tennis and Croquet in Onslow Gardens, *c.* 1900
Onslow Gardens were made up of a series of grand terraces (1865) overlooking communal gardens at the back, rather than the traditional garden in a square at the front. Victorian and Edwardian residents enjoyed a variety of sporting activities in the gardens.

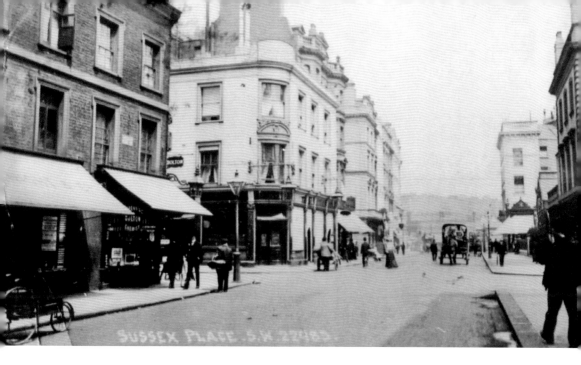

Sussex Place (Old Brompton Road), by Bute Street, c. 1906
The corners of Bute Street have retained surviving houses from 1847; these include the Zetland Arms, a traditional pub that continues to flourish. Further along is the projecting end of Onslow Crescent (now Melton Court) and the glass conservatory belonging to Wills & Segar, florist's. (*Courtesy Maurice Friedman*)

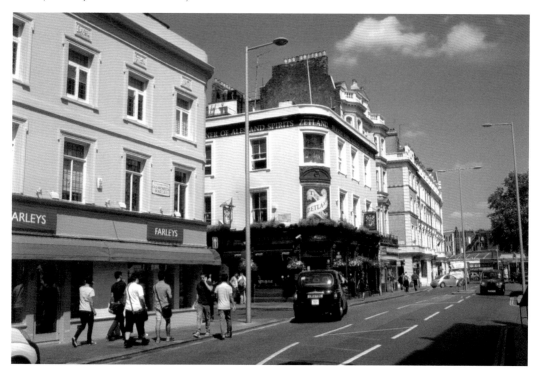

Sumner Place, c. 1906

A passing century has seen changes to these early Victorian houses, noticeably at the attic level. An all-over paint job has also given greater unity to the terrace than was possible with the individual efforts of old. The arched entrance to Sumner Place Mews was in particular need of the painter's brush. The Zetland Arms appears again in the distance.

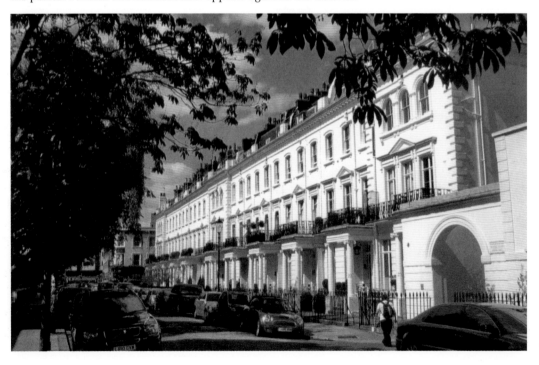

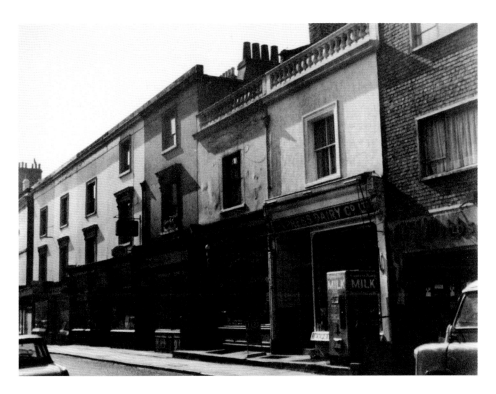

Bute Street, c. 1963

A street of small shops from 1847, with a name that celebrates the former Bute House, which stood from 1779 to 1874. Much of the street was war damaged and it was partly rebuilt in 1953 – the rebuilding extending to the rest of the street around 1965. The last of the old shops are seen here in their final months.

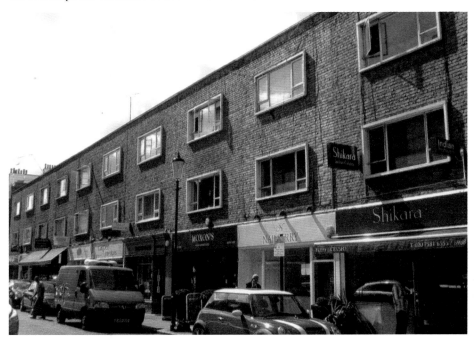

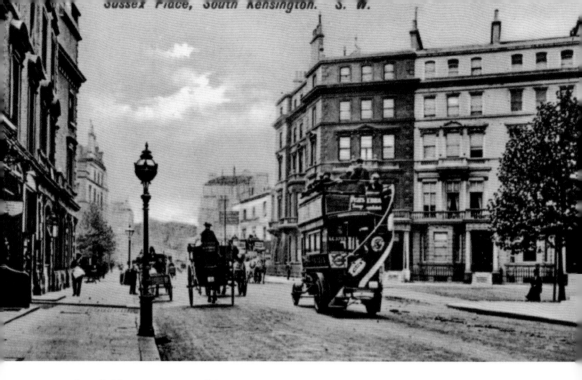

Sussex Place (Old Brompton Road) by Queen's Gate, *c.* 1906
This was another of Brompton's meandering rural roads before Victorian builders began to give it a more urban look. The street was once made up of individually named and numbered terraces or blocks of houses, including Gloucester Terrace, Moreton Terrace and Sussex Place. It was all simplified in 1939 when 'Old Brompton Road' was officially adopted for the whole street.

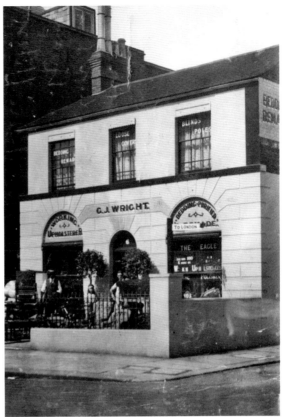

**No. 6 Gloucester Terrace
(No. 106 Old Brompton Road),
by Clareville Grove, c. 1920**
This house was a relic from the
days when spacious country houses
adorned Brompton's semi-rural
landscape. All have now gone, with
this example spending its last years in
commercial occupation, with Gilbert
J. Wright, upholsterer, in residence.
The house had gone by 1930 as Brew
Bros opened their 'motor spirit service
station' here.

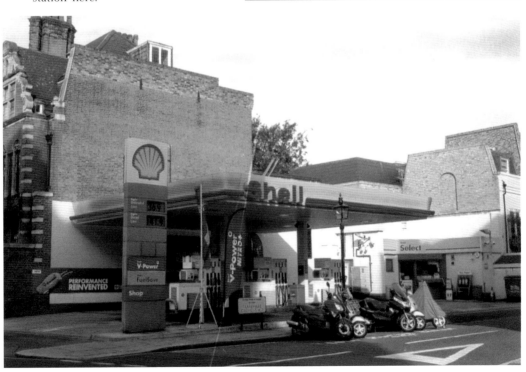

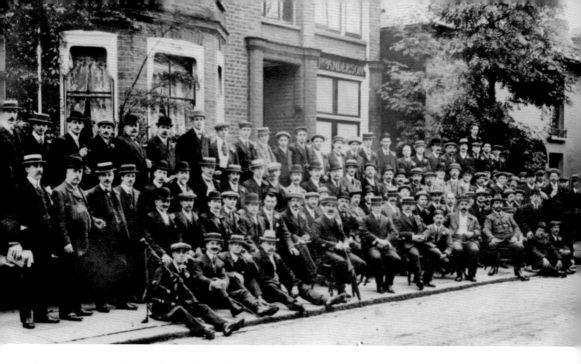

No. 3, Gloucester Grove West (Clareville Grove), c. 1907
The workforce of John Anderson, builders and decorators, assemble for their photograph before departing for the firm's outing. Note that almost everyone is wearing a hat and there is a piper on hand to enliven proceedings. The street dates from around 1825 and was residential in status, although some commercial interests moved in later, with a chimney sweep at No. 15 and a jobmaster sharing the premises at No. 3. A jobmaster was one who supplied working horses.

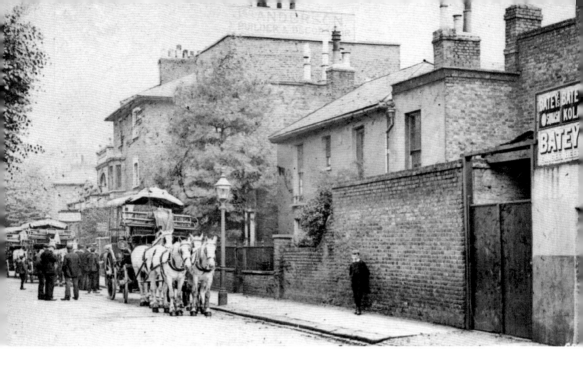

Gloucester Place West (Clareville Grove), 1907

Another look at Anderson's jolly day out with the horse-brakes lined up in readiness. Having regained its residential status, this leafy street's houses have been well preserved and the now rare square-lanterned street lamps have also been retained. The multifaceted Edwardian lamps that typified Kensington are more usually found in local conservation areas.

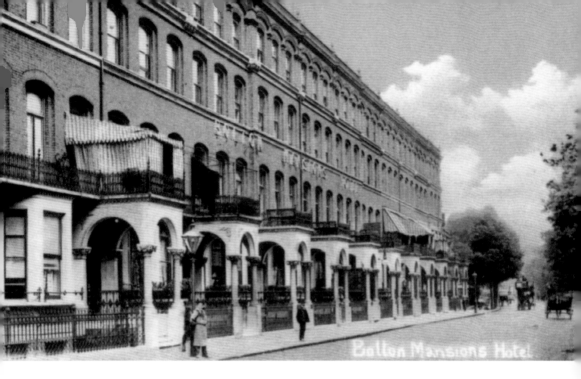

Bolton Mansions Hotel (Boltons Court), Old Brompton Road, c. 1907
With its multiple attractions, South Kensington continues to entice visitors from near and far, and there is a variety of hotels to cater for them. Some are purpose-built while others, as here, were made by joining together terraced houses.

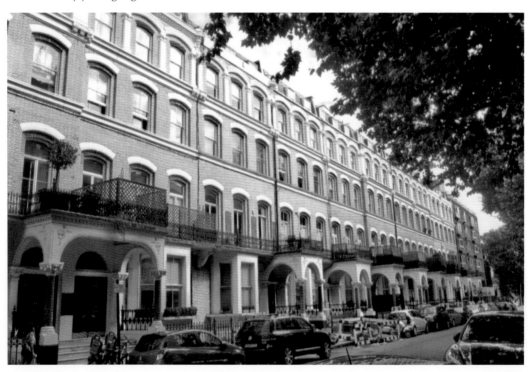

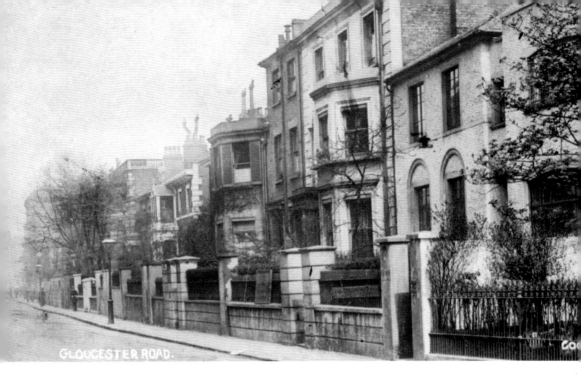

GLOUCESTER ROAD.

Gloucester Road Near Hereford Square, *c.* 1906

At the dawn of the nineteenth century, Hogmire Lane still wound its way through fields and market gardens, but changes were at hand and by the 1820s, smart new villas were springing up and there was a new name to reflect a more urbane image, Gloucester Road. The houses made up an attractively leafy neighbourhood running back to Clareville Grove, but part of the legacy was lost to war damage.

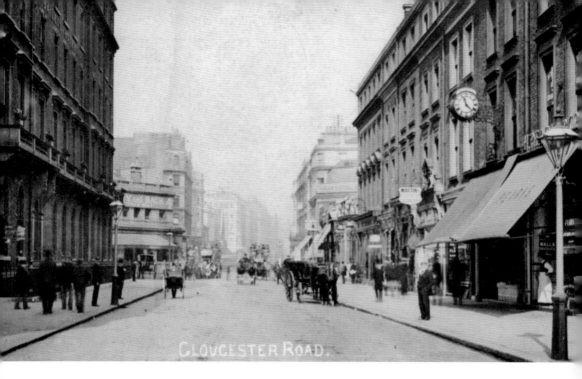

Gloucester Road from Stanhope Gardens, c. 1906
Bailey's Hotel (1876) stands opposite a long row of Victorian shops where a clock highlights
the premises of Wyatt's, the fishmonger's. The shop of Martin & Martin, saddlers and harness
makers, is also visible. Distant Gloucester Road Tube station (1868) is seen, but the advertised fare
of '4d to the City and back' has long been discontinued.

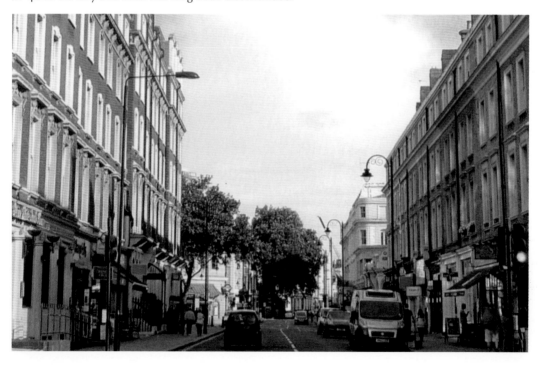

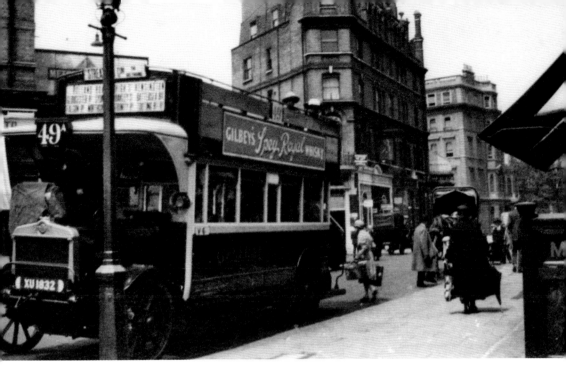

The No. 49 Bus, by Gloucester Road Station, *c.* 1928

Route 49 is one of a number of early services surviving from Edwardian days. The NS-type bus seen here was one of London's standardised models to retain an open upper deck, although many of them were subsequently roofed over as the fleet modernised in the 1930s. The No. 49 route remains a familiar sight in South Kensington.

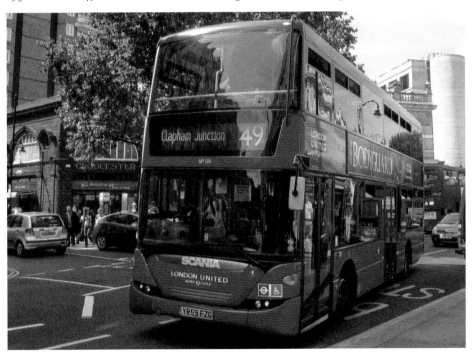

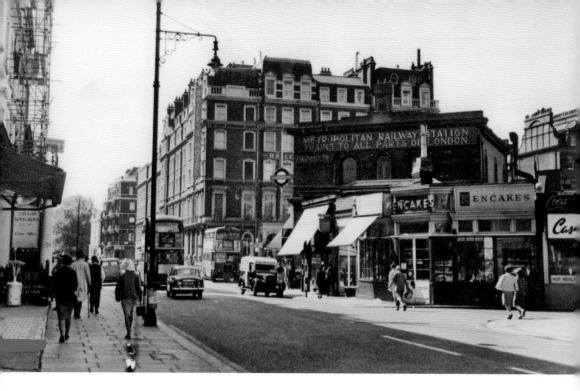

Gloucester Road, 1960s

Gloucester Road station is seen before restoration work gave it a bright new look. It opened in 1868 as 'Brompton (Gloucester Road)' on the Metropolitan Railway's line from Edgware Road. Rather than follow the street's building line, the station was placed at right angles to its subterranean tracks, resulting in an 'off-centre' look. The pre-restoration photograph shows the old shops that previously ran round into the now lost Lenthall Place.

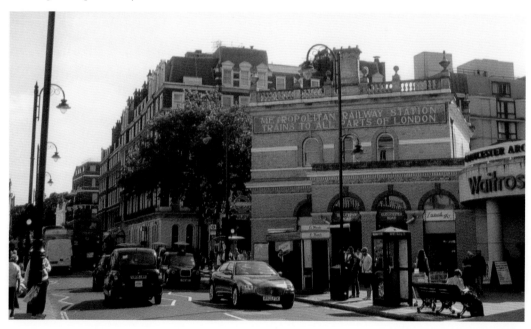

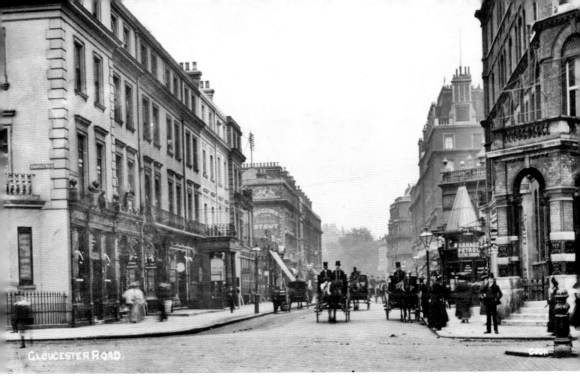

Gloucester Road Looking South from Cromwell Road, *c.* 1906
The classic shopping terrace on the left remains but, to the right, the imposing, porticoed building (1873) was replaced in 1991 by Gloucester Park and its new shopping arcade. Beyond is an impressively roofed telephone box; liveried coachmen complete an image of Edwardian elegance.

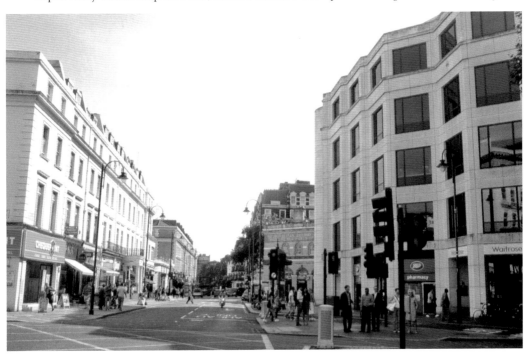

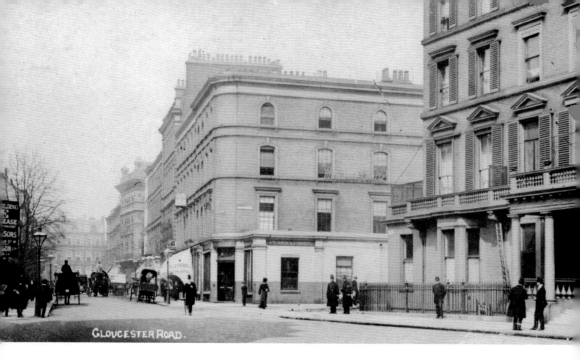

GLOUCESTER ROAD.

Gloucester Road by Elvaston Place, *c.* 1906

An estate agent's board signals the end of the road for St George's Terrace left an early terrace that featured lengthy front gardens. It was replaced in 1907 by St George's Court, a residential block that combined Edwardian flamboyance with ground-floor shops. A more traditional row of shops stood opposite.

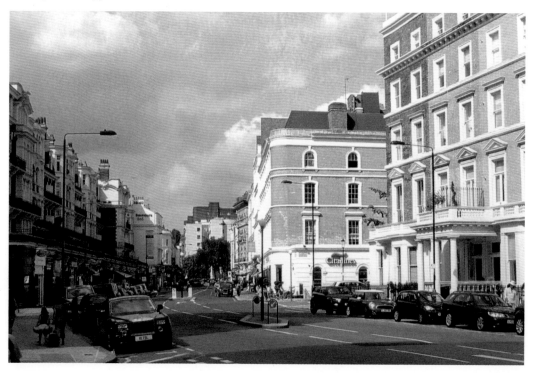

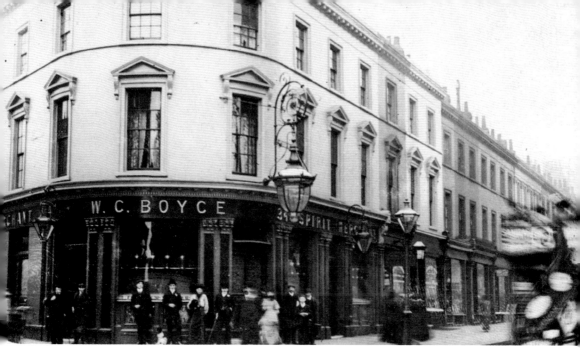

Gloucester Road by Victoria Grove, *c.* 1906
Built around 1839, this was Gloucester Road's first shopping terrace – it is still distinguished by the Gloucester Arms, a pub that elegantly turns the corner into Victoria Grove. The landlord in 1906 was William Boyce, who was doubtless one of those gathered outside.

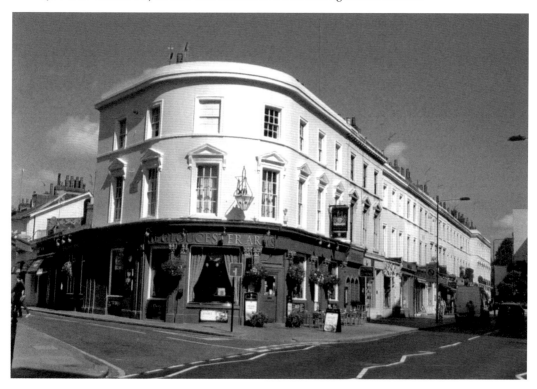

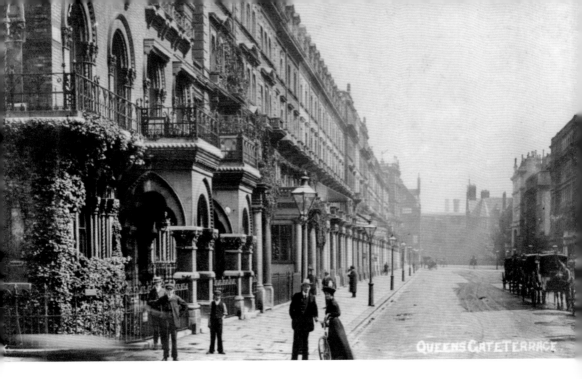

Queen's Gate Terrace, c. 1905

A spacious street of grand Italianate townhouses, with the South Kensington Hotel on the right. Most of the houses were built in the 1850s, apart from the Venetian Gothic example on the Gloucester Road corner (left), a later addition from 1863. The cab rank on the right has given way to regular street parking.

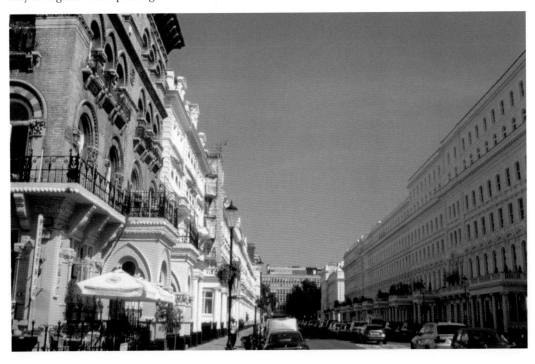

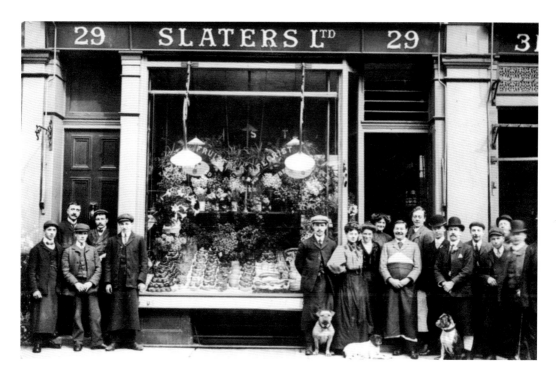

Slaters Ltd, No. 29 Gloucester Road, *c.* 1907

Slaters Ltd was a large business whose shops were a familiar sight in west London. Branches in Gloucester Road kept local residents well supplied with flowers, fruit, fish, butchers' products and general provisions. The flower and fruit shop seen here was part of a Victorian shopping row, which has since been rebuilt behind a preserved façade.

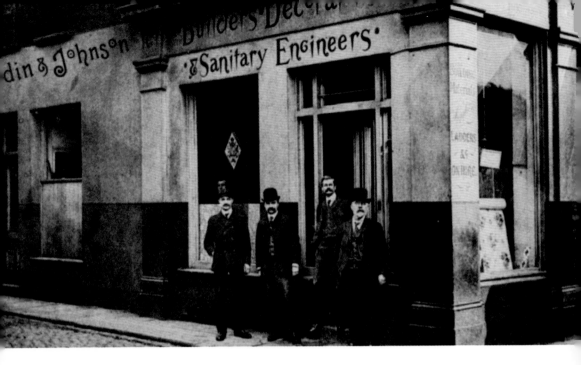

No. 1 Gloucester Road by Queen's Gate Mews, c. 1908
A one-time fishmonger's shop is seen here with builders and sanitary engineers Aldin & Johnson in residence. Later years brought motor engineer's garages, and a pet shop traded here in post-war years.

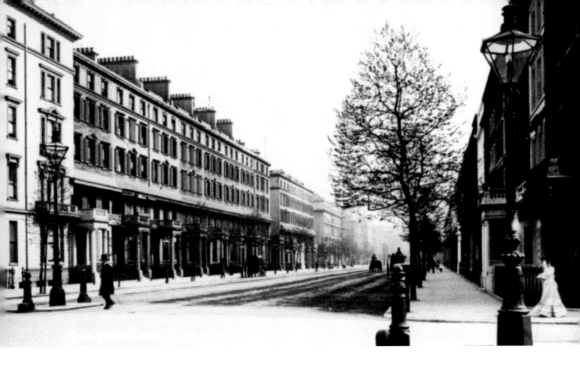

Queen's Gate from Cromwell Road, *c.* 1905
Originally called Prince Albert Road, the street was soon renamed in honour of Queen Victoria. The wide and spacious thoroughfare is mostly made up of classic Italianate houses in the typical Kensington style. The terrace on the left runs down to Queensberry Mews West and Harrington Road, but a passing century has seen the removal of all the window shutters and balcony awnings, while car parking has claimed the centre of the roadway.

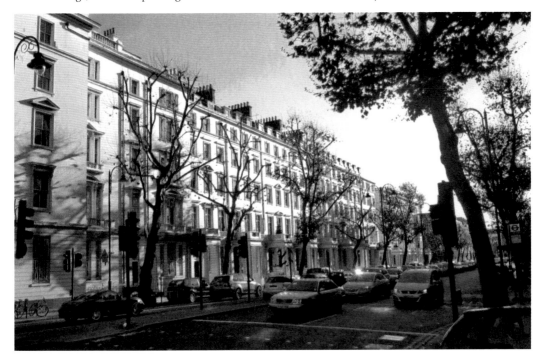

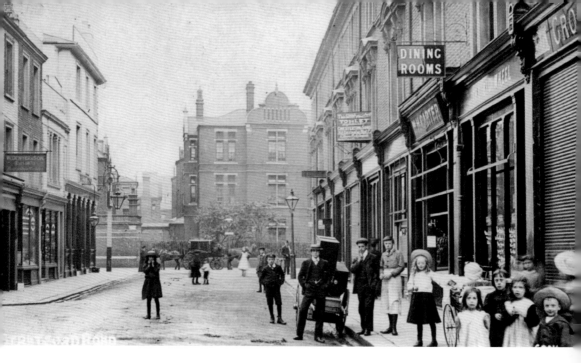

Stratford Road, *c.* 1906

A collection of neighbourhood shops is seen here when a portable street piano or barrel organ had attracted the younger element. These musical contributions were not always welcome, however, and many houses put up signs requesting that street musicians should desist. Dining rooms and an open-fronted butcher's shop are on view here, and there is a distant sight of St Mary Abbots Hospital, which began life in 1849 as Kensington Workhouse. The hospital moved away in 1993.

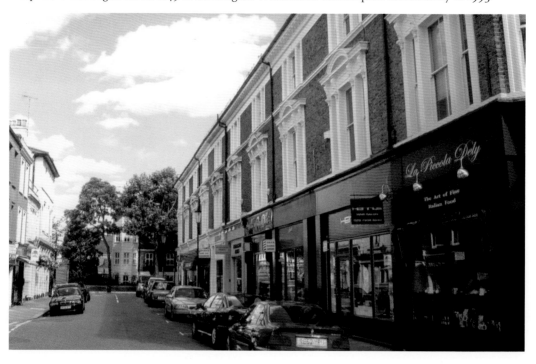

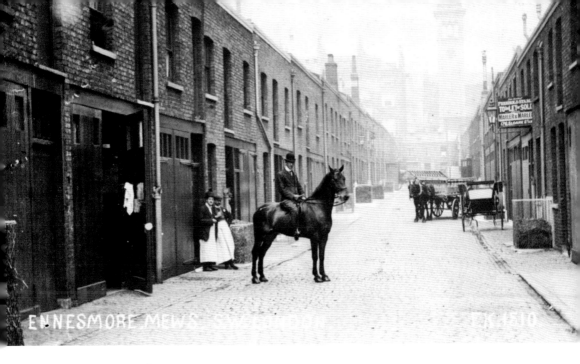

Ennismore Gardens Mews, c. 1904

Mews streets are as much a part of the South Kensington townscape as its great set piece terraces and smart shops. These stone-cobbled former stables and coach houses hide away behind rows of tall town houses and were the abode of coachmen and stable workers. As reliance upon the horse declined in the early 1900s, old mews properties were readily adapted for the motor car, with limousines and chauffeurs to be seen alongside motor garages and repair shops. Once more, this usage died away and with a post-war trend towards fashionable town centre living, many mews were transformed into picturesque byways lined by expensive bijou homes. The lost equine world of Ennismore Gardens Mews is seen here.

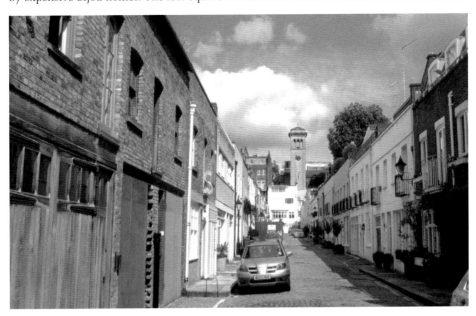

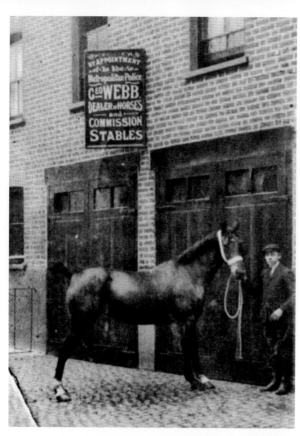

George Webb, Horse Dealer, Nos 2–6 Coleherne Mews, Wharfedale Street, c. 1906
George Webb's business prospered in horse-dominated Edwardian London, where he operated by appointment to supply horses to the Metropolitan Police. A typical sequence of later occupation at this address first brought a motor garage, with conversion to residential by at least 1940.

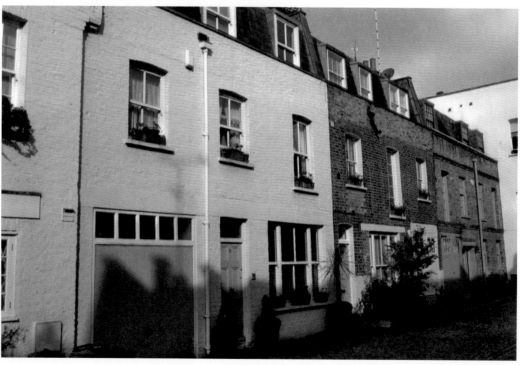

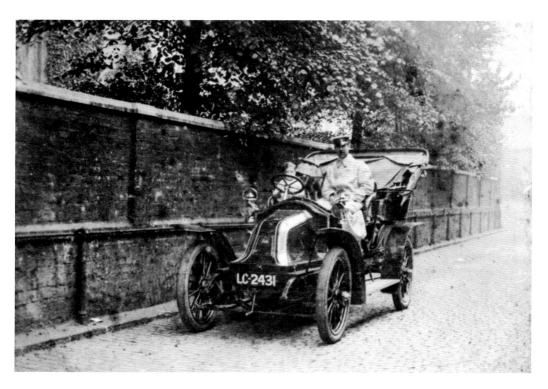

Cornwall (Kynance) Mews, *c.* 1907

Built during the 1860s to serve the houses of Cornwall Gardens, part of the mews is seen here as it entered the motoring age, where old stables were already finding new roles as garages. This mews has long been noted for its attractive house conversions, with a view of Christ Church, Victoria Road (1851), adding to the ambience.

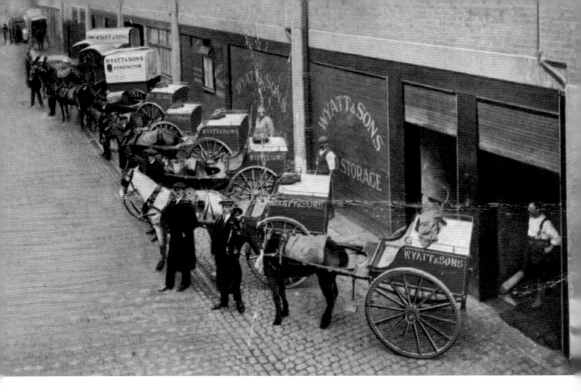

James Wyatt & Sons, Butcher's, Fishmonger's and Poulterer's, Stanhope Mews West, *c.* 1906
This firm's shop was at No. 107 Gloucester Road, but there were also storage and stabling facilities in the mews that ran behind the shop. In post-war years, the mews degenerated into a grim and malodourous byway, but modern properties have since given it a bright, fresh new look.

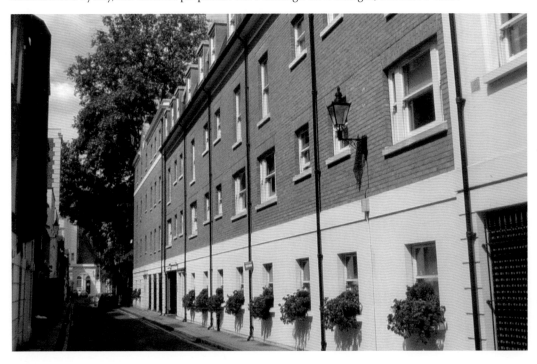

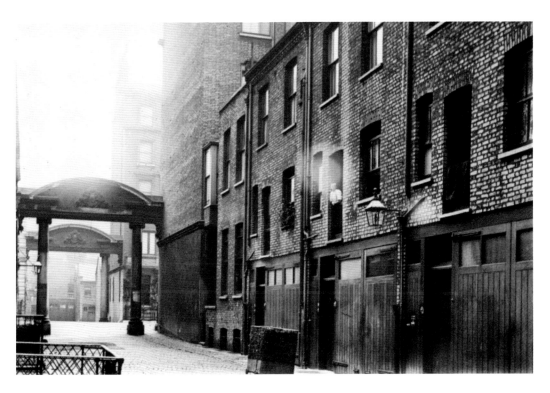

Elvaston Mews, Elvaston Place, c. 1910
A characteristic of many Kensington mews are the arched entrances, which were provided to partly screen the lowly worlds of stables and coach houses from the houses they served. The two parts of Elvaston Mews had classically designed arches (one survives), while the northern part of the mews, seen here, sported unusual double-height accommodation above the stables.

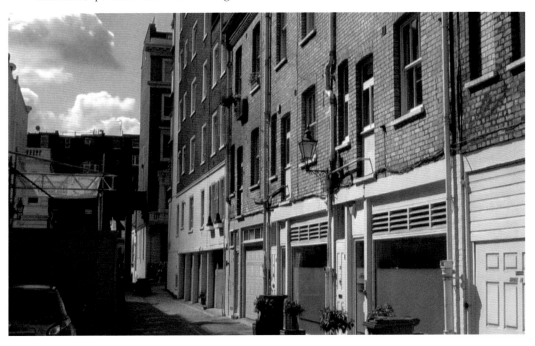

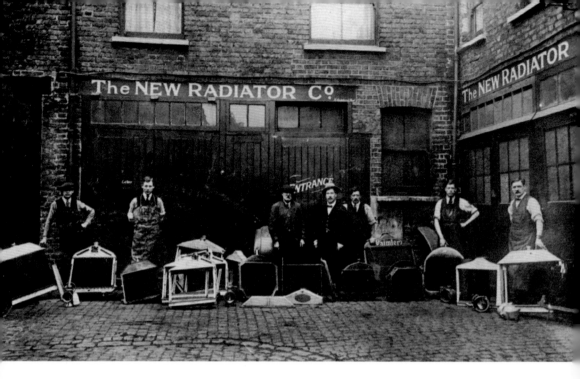

The New Radiator Co., Radley Mews, c. 1920
Redundant mews stables were readily converted to garages and other businesses relating to the rapidly developing motor trade. Here, proprietor H. Goddard's company also specialised in car lamps, and was one of a number of such businesses in Radley Mews. The horse had not been entirely banished and there was a farrier still trading here into the 1930s.

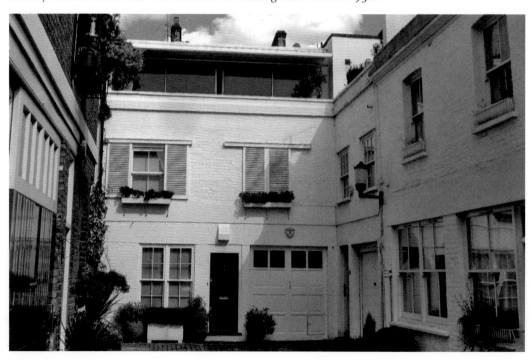

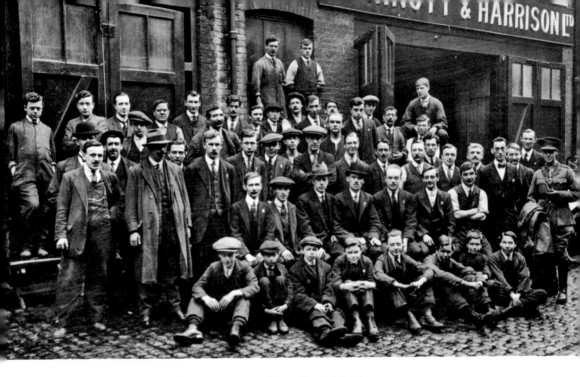

Arnott & Harrison Ltd, Motor Car Repairers, Kendrick Mews, *c.* 1917
A large workforce for a typical enterprise as the motoring age took hold. The early motor car was sometimes an unreliable beast, requiring much attention to keep it mobile. In later years, this type of mews business dwindled away as mews became increasingly fashionable places to live.

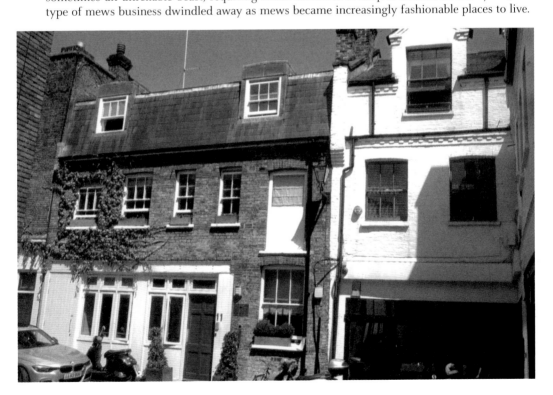

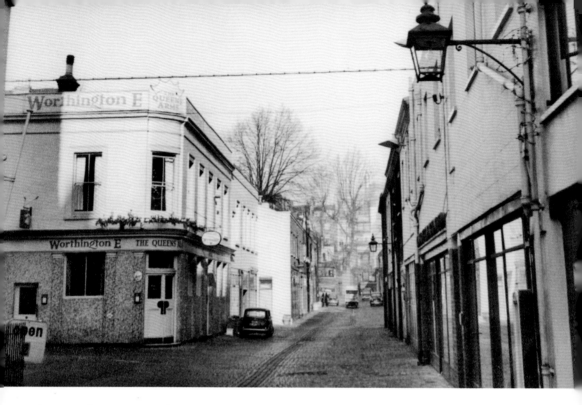

The Queen's Arms, Queen's Gate Mews, 1960s
This is another mews that emerged from its equine origins to become a stronghold of the motor trade, complete with its own petrol filling station. There was also this rare mews pub, which continues to delight with its floral displays. Its original clientele would have included coachmen and stable hands.

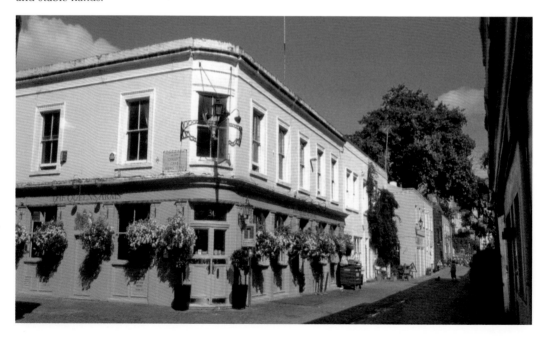

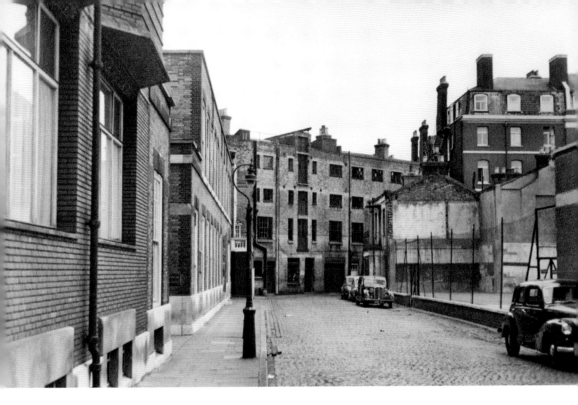

Queensberry Way, 1961

This is an example of a mews that has gradually lost all the characteristics of such streets. It originated as part of Queensberry Mews East, but changes began in 1935 with the building of the Lycée Français on its Queensberry Place corner; a classroom block followed along the mews in 1938. By the 1960s, most of the remaining mews houses had given way to a new playground for the school, and the end building, an engineering works, was then demolished, opening the way into Cromwell Mews.

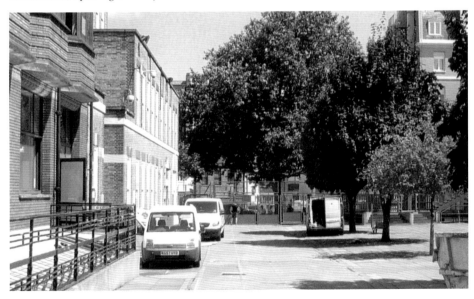

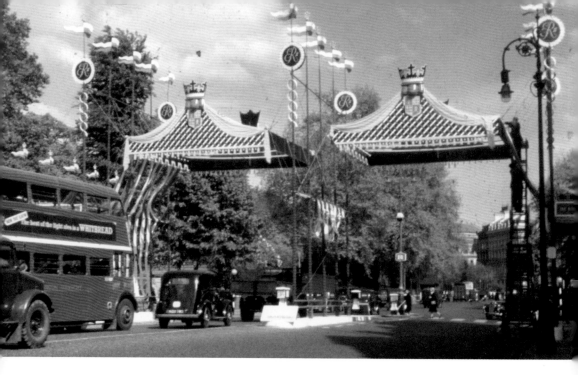

The Coronation Arch, by Kensington Gardens, June 1953

The title 'Royal Borough' was bestowed upon Kensington by Queen Victoria, who spent her childhood years at Kensington Palace. Close by, the dawn of a new Elizabethan age was celebrated in style with this ceremonial arch; Queen Elizabeth II was crowned in Westminster Abbey in June 1953. Part of the design for Kensington's arch recalled the tournament pavilions of the first Elizabethan era (1558–1603). In the present day, the roadway is spanned once more by another temporary arch, this time to facilitate a building project.